DRAWING EXPRESSIVE PORTRAITS

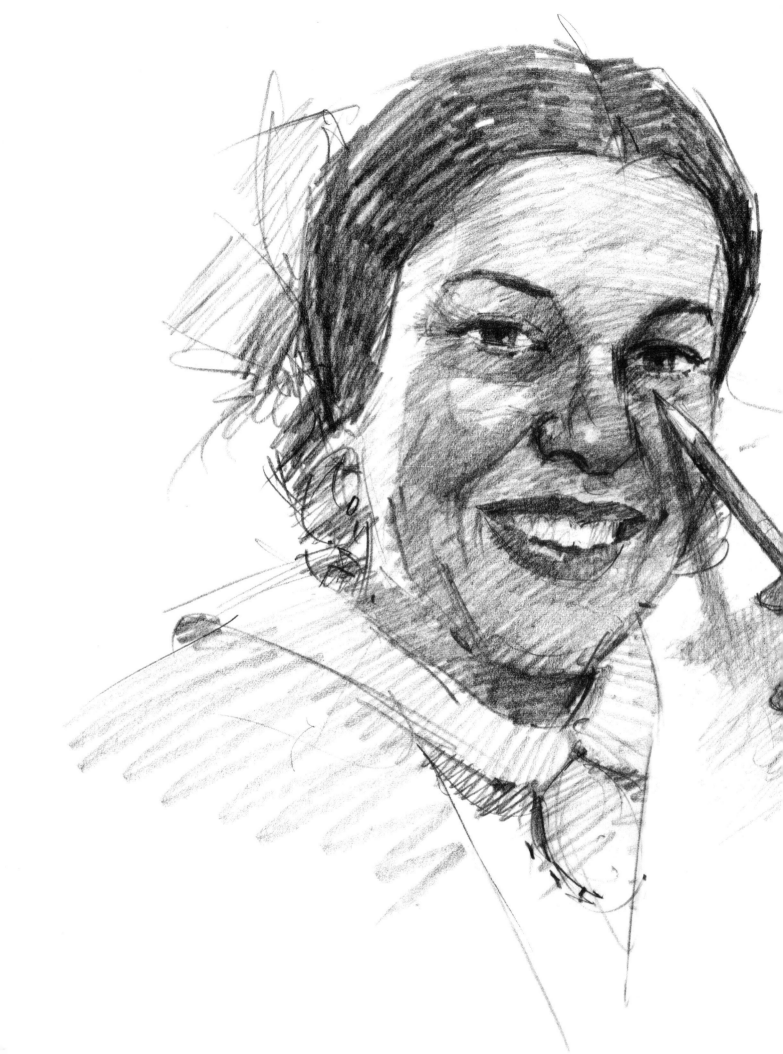

DRAWING
Expressive
Portraits

PAUL LEVEILLE

NORTH LIGHT BOOKS
Cincinnati, Ohio
www.artistsnetwork.com

ABOUT THE AUTHOR

In his studio nestled in the hills of western Massachusetts, Paul Leveille paints the portraits of nationally and internationally distinguished clients.

Paul has been pursuing his love of portraiture since 1980. Before that, he spent twelve years as an art director and illustrator in advertising.

Paul is a graduate of the Vesper George School of Art in Boston. He is a member of the Copley Society, Boston; the Academic Art Association of Springfield, Massachusetts; the Springfield Art League; the Rockport Art Association, Rockport, Massachusetts; the Connecticut Pastel Society; and the Oil Painters of America.

In addition to his portrait commissions, Paul conducts portrait painting workshops and portrait demonstrations around the country. He has also produced a seventy-minute instructional video entitled "Portrait Demonstration in Oils."

Paul lives with his wife and daughter in West Holyoke, Massachusetts.

METRIC CONVERSION CHART

to convert	to	multiply by
Inches	Centimeters	2.54
Centimeters	Inches	0.4

Drawing Expressive Portraits. Copyright © 1996 by Paul Leveille. Manufactured in China. All rights reserved. No part of this book may be reproduced in any form or by any electronic or mechanical means including information storage and retrieval systems without permission in writing from the publisher, except by a reviewer, who may quote brief passages in a review. Published by North Light Books, an imprint of F+W Publications, Inc., 4700 East Galbraith Road, Cincinnati, Ohio 45236. (800) 289-0963. First paperback edition 2001.

Other fine North Light Books are available from your local bookstore, art supply store or direct from the publisher.

16 15 14 13 12

Library of Congress has catalogued hard cover edition as follows:

Leveille, Paul.
 Drawing expressive portraits / by Paul Leveille.—1st ed.
 p. cm.
 Includes index.
 ISBN-13: 978-0-89134-614-2 (hc.: alk. paper)
 ISBN-10: 0-89134-614-7 (hc.: alk. paper)
 1. Portrait drawing—Technique. I. Title.
NC773.L48 1995
743'.42—dc20 95-21842
 ISBN-13: 978-1-58180-245-0 (pbk.: alk. paper) CIP
 ISBN-10: 1-58180-245-5 (pbk.: alk. paper)

Edited by Rachel Wolf and Kathy Kipp
Cover and interior design by Brian Roeth

F+W PUBLICATIONS, INC.

For my mother and father who always encouraged me and led me to believe that the occupation of artist was a very important one.

ACKNOWLEDGMENTS

Working on this book was a great pleasure and eye opener for me. On one hand, I did not anticipate the immense amount of work and time necessary to produce this book. On the other hand, everything from the drawings and writing, to the wonderful people I've met, has enriched my life.

I owe a great deal of thanks to my editors Rachel Wolf and Kathy Kipp for their endless patience, sensitive direction and positive reassurance throughout the process. I'm also convinced that there would be no book except for the unfaltering love and support from my best friend and wife, Pat...not to mention her faultless typing. And last, a special thanks to all those who allowed me to draw their beautiful faces.

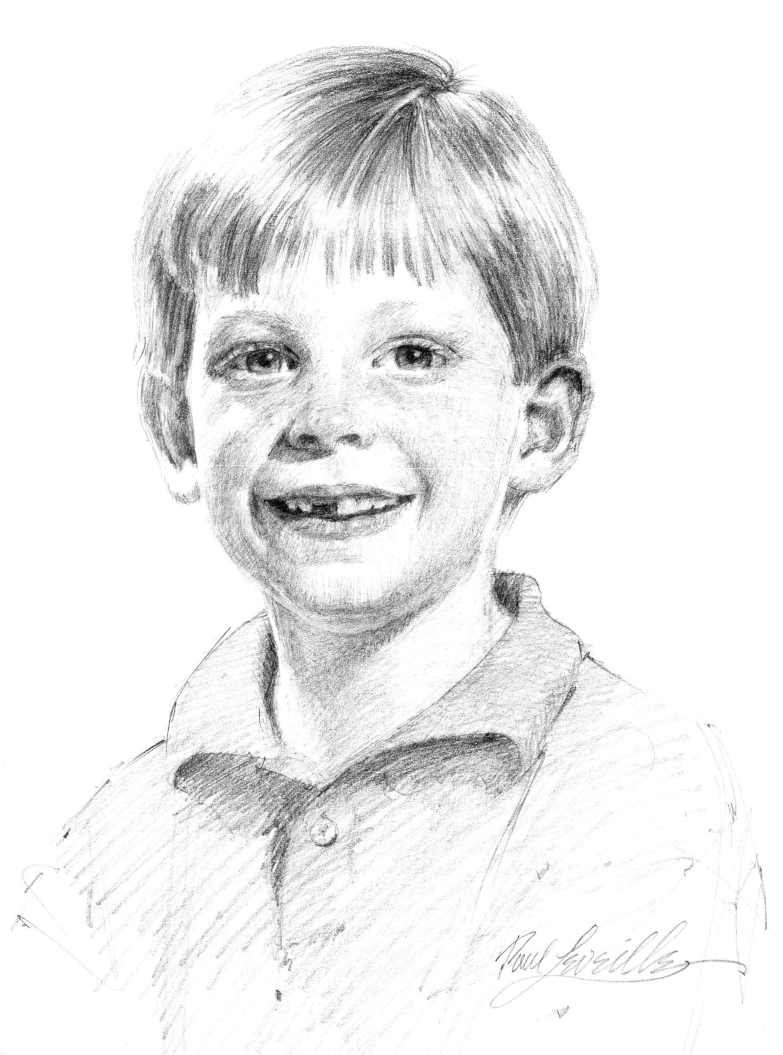

TABLE OF CONTENTS

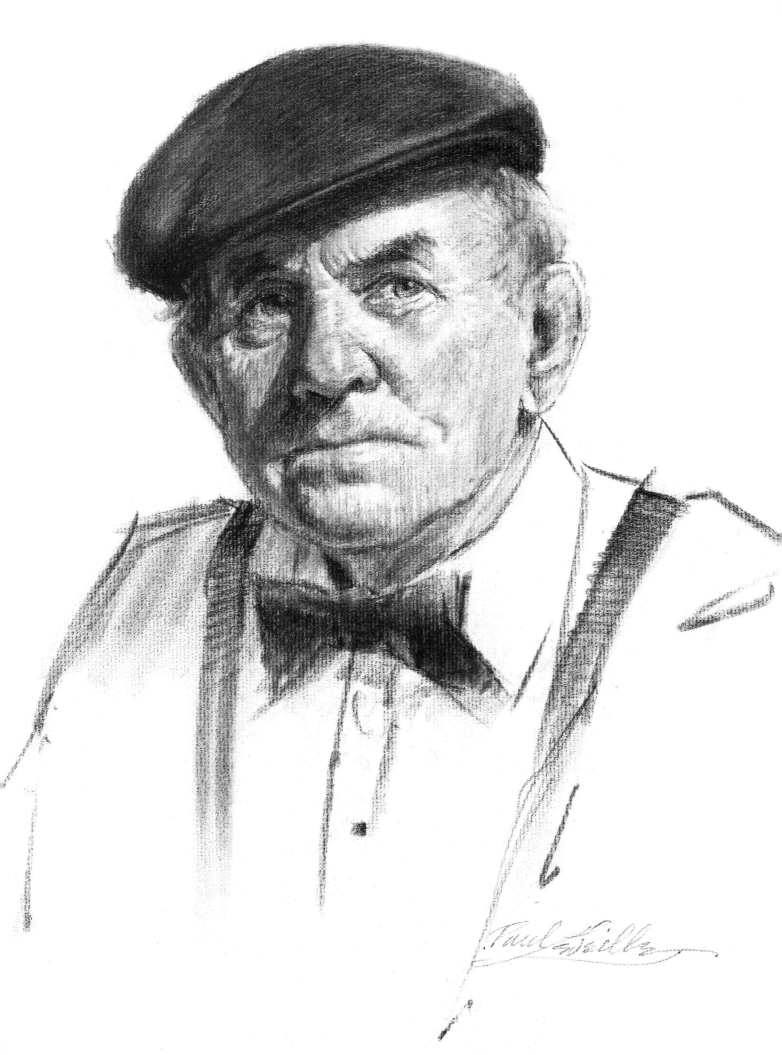

Squatting in back of the golf ball, I look to see the path the ball must take to fall into the cup. I set up my stance and adjust my grip on the club. I *look* at the hole, then the ball, then the hole. Now I can *see* what I have to do. The club swings and strikes the ball. The ball rolls toward the hole. It's rolling, rolling...it falls short. Guess I need more practice.

In drawing, as in golf, seeing is very important. But all the seeing in the world won't help you in golf or drawing if you don't practice. The more you draw, the more your hand-eye coordination will improve.

Drawing the human head correctly takes practice, but I never consider it work. To me, people are the most fascinating subjects to study and draw. There is no chance for boredom since there are millions of faces in this world and all are different. Even the same person takes on many looks by changing expressions, clothing and lighting.

One way to increase your pleasure when drawing a portrait is to forget about creating a likeness. Instead, concentrate on seeing and drawing the big shapes of dark and light. Work broadly at first, then slowly refine things as you go along and the likeness will follow.

While learning to draw portraits, remember that you are not in a race. Relax and progress at your own pace. As long as you keep drawing, you will move forward. So pick up your pencil and enjoy the journey!

Setting Up

ESSENTIAL MATERIALS

Drawing Pencils

Drawing pencils come in various degrees of hardness and softness. 2B, 4B and 6B are soft lead pencils that are excellent for achieving bold, dark strokes. The hard lead pencils, such as 2H, 4H and 6H, are recommended for light, crisp lines.

Charcoal

Vine charcoal comes in sticks of various thicknesses. It is available in soft, medium or hard density and is ideal for starting drawings. Corrections can be made quickly because vine charcoal erases easily.

Compressed charcoal produces a dense, black tone. It is available in several degrees of density.

Pencil/Charcoal Holder

A pencil holder has a slim wooden handle with an adjustable metal end. A short pencil can have a new life by inserting it in the metal end of the holder, making it longer and easier to hold. A charcoal holder is similar to a pencil holder. It holds a piece of charcoal, allowing you to work at arm's length.

Kneaded Eraser

Kneaded erasers are soft and can be kneaded into any shape. Excellent for removing charcoal or pencil, they can also be used to lift charcoal or pencil to leave a highlight.

Pink Eraser

Pink erasers are pliable and are beveled at both ends. They can be used to remove more stubborn pencil or charcoal marks.

Masking Tape

Masking tape comes in various widths and is handy for taping drawing paper to drawing boards.

X-Acto Knife

An X-Acto knife has a metal cylindrical handle like a pencil and a one-inch-long pointed blade at one end. Blades are changeable. This is a very handy tool for detail cutting or for sharpening charcoal or pencils.

Sandpaper Block

A sandpaper block is handy for sharpening a piece of vine charcoal or a pencil. It's made of strips of sandpaper stapled to a thin piece of wood that can be held in one hand. By rubbing the tip of your pencil over the sandpaper, you can get a fine point or a chisel edge.

Utility Knife

A utility knife is a heavy-duty knife. The handle fits nicely in the palm of your hand. It is very useful for cutting mat board and for general use.

Ruler

In addition to being a measuring tool, a ruler is ideal as a straightedge for drawing and cutting.

Paper

There are many fine papers for charcoal and pencil drawing. Some of them will be discussed in chapter one.

Mat Board

Mat boards are dense boards made of compressed paper. They come in many colors. More information is available on pages 124-125, "Matting and Framing Your Artwork."

Foamcore Board

Foamcore board is a white, lightweight board useful when mounting and matting artwork. It also can be used to reflect light when lighting a model.

Spotlight

You'll need a spotlight to light your models. You can purchase a lamp with a tripod in most art supply stores. A clip-on lamp (without a tripod) can be purchased in most hardware stores.

Drawing Table

An artist's drawing table can be raised to different heights and can be tilted to suit your situation.

EXTRAS

Charcoal Pencils

Charcoal pencils, like lead pencils, are available in different densities. Softer charcoal pencils are identified as 2B, 3B, 4B, etc. The higher the number, the softer the charcoal. Harder charcoal pencils are identified as 2H, 3H, 4H, etc. The higher the number, the harder the charcoal.

Stumps

Stumps are solid, rolled felt paper that comes to a point at each end. They are used for blending and can be sharpened to a new point in a pencil sharpener.

Tortillions

Tortillions are soft felt paper, rolled and pointed at only one end. They are used for blending and softening edges in charcoal and pencil drawings.

Gummed Cloth Tape

Gummed cloth tape is a very strong tape that is water activated and is acid free. It's used primarily to attach artwork to a mat when framing.

Razor Blade

A single-edge razor blade is excellent for sharpening pencils or cutting paper.

Tracing Paper

Tracing paper is a thin, transparent paper that is excellent for tracing and refining your drawings. It can be purchased in pads and rolls.

Easel

Easels come in a variety of styles and price ranges. A simple easel that holds a pad or drawing board is sufficient for charcoal and pencil work. Standing at an easel allows you to use your arms and body as well as your hands to create a dynamic drawing.

Model Stand

A model stand is a platform about twelve inches to sixteen inches high and wide enough to accommodate a chair for a model to sit on.

Camera

A 35mm camera with a 70-200mm zoom lens or a 105mm lens is useful for photographing models.

Hot Glue Gun

A hot glue gun is useful when you mat a drawing.

White Glue

White glue is useful for applying backing paper to framed artwork.

STUDIO

It's important to have a place where you can draw, a place where you can leave your drawing materials out. You don't need a large space, just room enough for a drawing table or desk and a chair, placed by a window if possible. I know of one artist who started out by setting up his desk in an empty closet. Only his chair was in the room. He also had bookshelves and storage space above and to the sides of his desk. Wherever you find room, it should be a place where you can spend time drawing alone and uninterrupted. This rules out the kitchen table.

Some people have limited time to spend at their art because of other commitments—family, jobs, etc. At times you may think, *This is a good time to draw*, but the thought of pulling out all your equipment and setting up your table might be enough to dampen your enthusiasm. All the more reason to have an area set up for drawing, where you can leave a drawing in progress today and pick it up again tomorrow.

A Private Space

When I was a boy living at home, there was a walk-in attic off the bedroom that I shared with my brother. It was full of "attic stuff." I decided I needed privacy to draw, so I sectioned off a little studio space in the attic. A piece of old plywood screwed against the wall was my desk. The old spinning piano stool was my "director's chair." Like most attics, this one was not insulated, so I worked at my drawing desk wearing hat and jacket during the colder months and shorts during the summer. But, you know, I never felt inconvenienced. My "studio" was private and it was mine!

Drawing on Location

Not all work has to be done in your studio. Drawing on location is a wonderful way to work. A subway, an airport, a cafe, the park—any place with people can become your studio. With sketch pad and pencil you can quickly interpret gestures, expressions, the way garments hang, the folds in clothing when people are moving or sitting or standing. This is not the time to be concerned with detail. You will have only a few minutes or seconds before your subjects move. Look for the biggest gestures, the biggest areas of light and dark. Work broadly to capture a pose or expression. You'll find that the more sketching you do, the more information you will be able to document in less time.

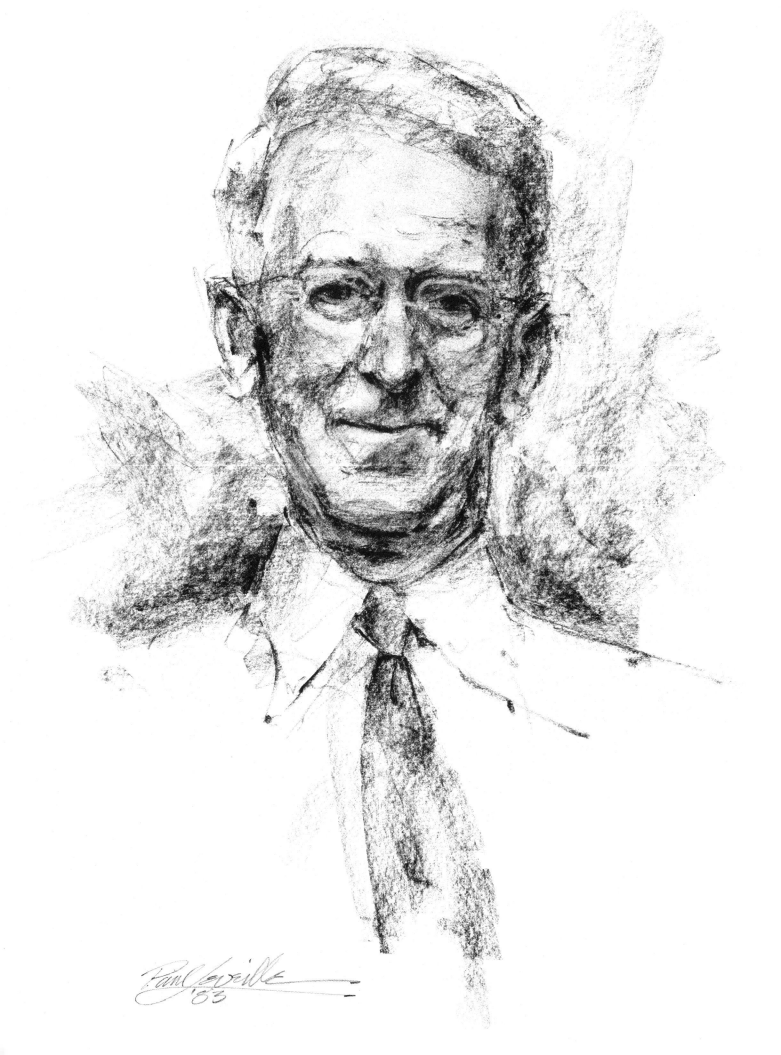

Basic Drawing Techniques

In golf, learning certain fundamental techniques involved in the grip, stance and swing helps to improve your game. The same is true of drawing. In this chapter I will introduce you to some of the drawing techniques that I find helpful. Although these techniques may save you some time in your drawing, there are no shortcuts to becoming proficient at drawing. The only way to get better at drawing is to draw, draw, draw!

◄

J.B.
Charcoal on a textured paper.

In addition to drawing with line, I used the side of a charcoal stick to quickly block in the large dark and midtone areas. With a kneaded eraser, I removed charcoal above and below the eyes to suggest his glasses. This is a loose drawing that has a spontaneity I like very much.

Pencil

Pencil is one of the most versatile and enjoyable mediums to work in. Since it's the first drawing and writing instrument most of us use, it's the most comfortable. There's little or no mess involved, you can carry a pencil anywhere, and since pencil drawing requires very little setup time, it's ideal for quick sketches.

You can achieve the most elaborate drawings with pencil. On the other hand, using pencil is so simple that you can document your travels by quick draw-

ings compiled in your sketch pads. Pencil is also a great idea medium, allowing you to put down your thoughts and concepts on paper (or napkins) quickly.

In addition to the traditional round lead pencil, you may want to add a few broad chisel-edged pencils to your supply. They are handy for laying in large toned areas quickly. Also, the many degrees of softness and hardness of pencil leads allow for a variety of handling techniques, a few of which are shown here.

LIGHT AND DARK AREAS
You can achieve a variety of light and dark areas by moving your pencil tip back and forth on the paper rapidly while increasing or decreasing pressure.

CROSSHATCHING
Drawing a series of lines in one direction and then crossing over them with another series of lines forms a grid pattern called crosshatching. This pattern can be crossed many more times in various directions to produce light to very dark areas.

SOFTENING CONTRAST
If you have a dark area that butts up to a light area, you may want to soften the contrast. By rubbing the area with your finger, a soft transition will appear.

BLENDING
Paper stumps or tortillions can also be used for blending.

LIFTING OUT LIGHT AREAS
To include a highlight or very light area on your drawing, lift the pencil or charcoal from the desired area with a kneaded eraser.
To lighten larger areas, lay the edge of a clean sheet of paper over part of your drawing and rub the kneaded eraser along the edge. You will get a crisp, clean edge.

USING A CHISEL-EDGE PENCIL
To get a chiseled look in your drawing, shave the end of your pencil with a utility blade or X-Acto knife. Then shape the pencil tip into a chisel shape by rubbing it on a sandpaper block (see page 16).

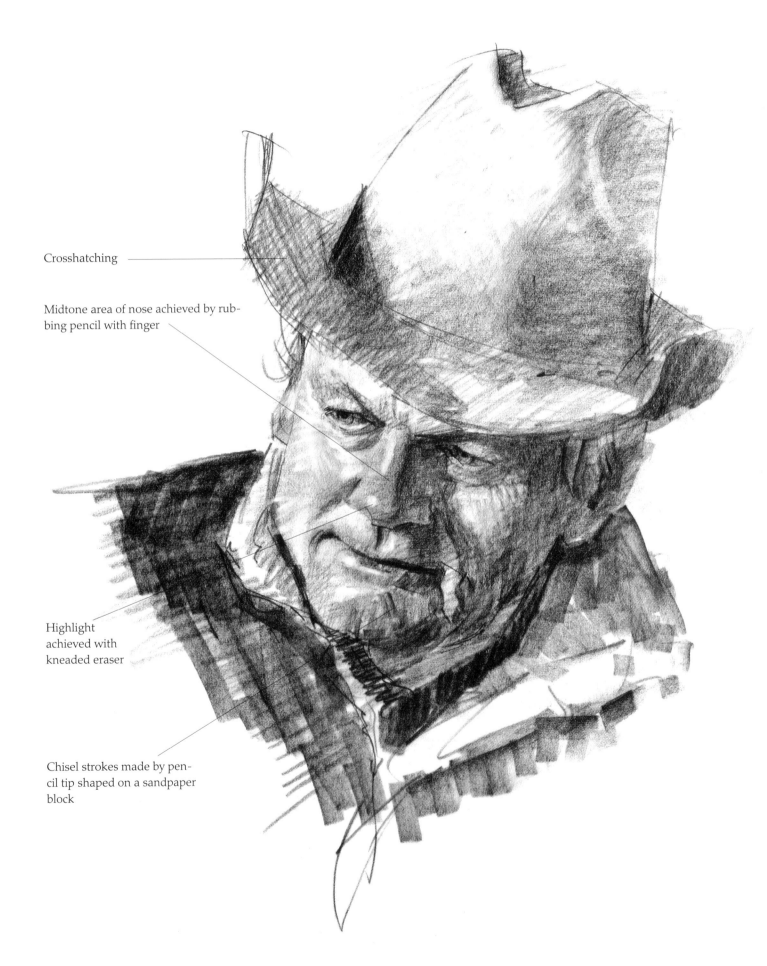

Crosshatching

Midtone area of nose achieved by rubbing pencil with finger

Highlight achieved with kneaded eraser

Chisel strokes made by pencil tip shaped on a sandpaper block

Charcoal

Charcoal is a joy to use. When standing at your easel, using a piece of vine charcoal encourages you to draw with your hand, arm and body to aggressively change from thin lines to broad strokes quickly. With the flowing, soft strokes of charcoal you can block in large medium-to-dark areas quickly. Deep, rich darks can be achieved with compressed charcoal. All in all, charcoal is a very satisfying medium to work with.

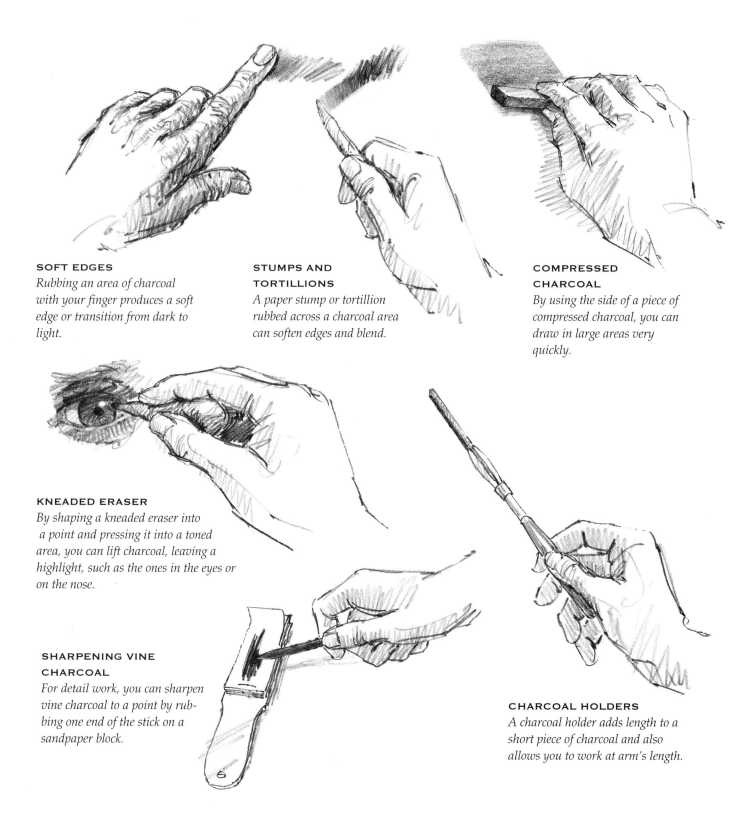

SOFT EDGES
Rubbing an area of charcoal with your finger produces a soft edge or transition from dark to light.

STUMPS AND TORTILLIONS
A paper stump or tortillion rubbed across a charcoal area can soften edges and blend.

COMPRESSED CHARCOAL
By using the side of a piece of compressed charcoal, you can draw in large areas very quickly.

KNEADED ERASER
By shaping a kneaded eraser into a point and pressing it into a toned area, you can lift charcoal, leaving a highlight, such as the ones in the eyes or on the nose.

SHARPENING VINE CHARCOAL
For detail work, you can sharpen vine charcoal to a point by rubbing one end of the stick on a sandpaper block.

CHARCOAL HOLDERS
A charcoal holder adds length to a short piece of charcoal and also allows you to work at arm's length.

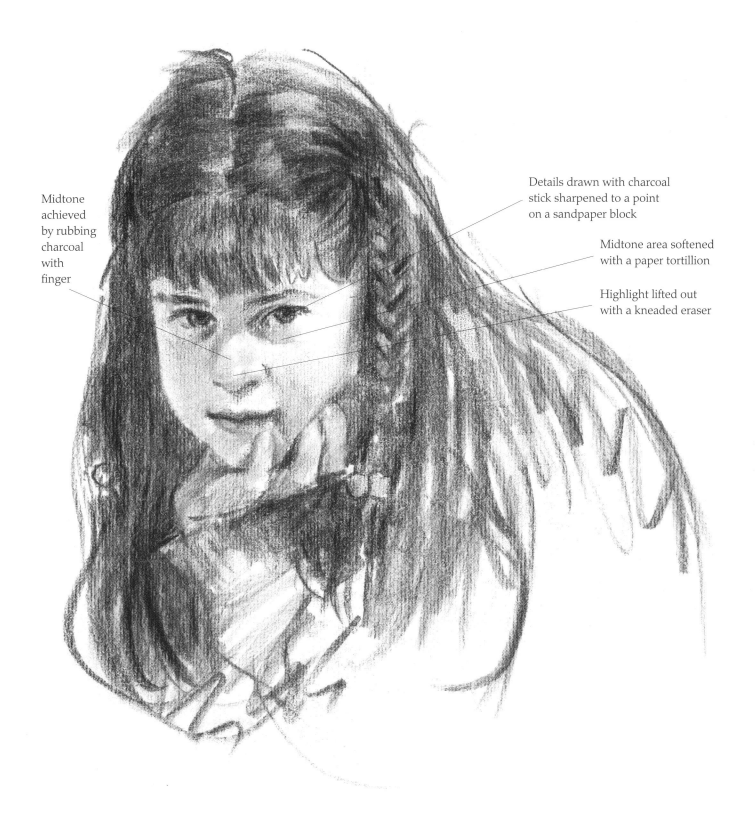

Midtone
achieved
by rubbing
charcoal
with
finger

Details drawn with charcoal
stick sharpened to a point
on a sandpaper block

Midtone area softened
with a paper tortillion

Highlight lifted out
with a kneaded eraser

Paper

If you were going to drive across the country, what type of car would make your trip more enjoyable, a new economical compact or a late model luxury car? My guess would be the luxury car. On the other hand, if you needed a vehicle for busy city driving and parking, perhaps the compact would be more convenient and easier to use.

Likewise, the type of paper you choose to work on has a direct bearing on the amount of pleasure you will receive from drawing. For example, if you want to do a small pencil drawing, a smooth plate-finished paper allows you to achieve more detail. On the other hand, the pronounced texture of papers like Canson Mi-Teintes and Canson Ingres is excellent for grabbing and holding the softer medium of charcoal. This texture is often referred to as the paper's "tooth." Experiment with these papers and any others you can find until you locate the ones that suit your style best.

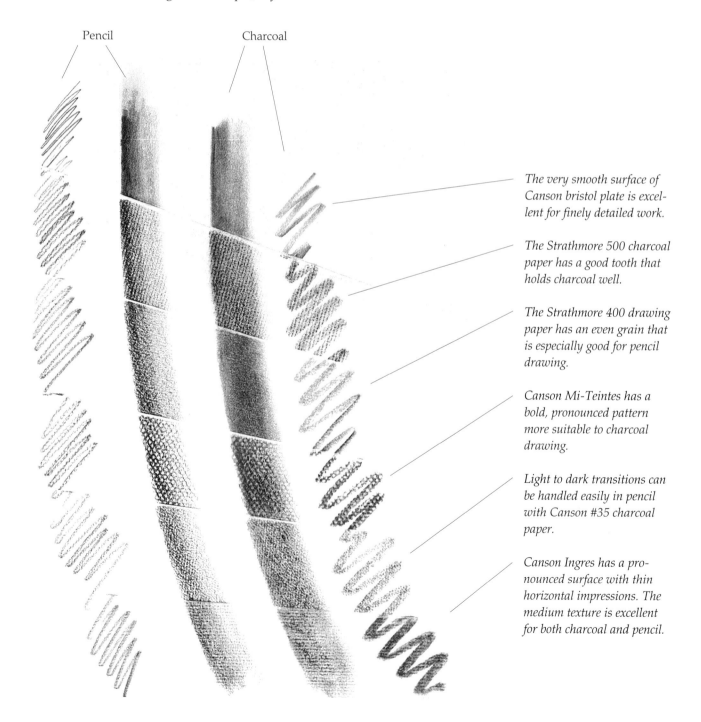

Pencil

Charcoal

The very smooth surface of Canson bristol plate is excellent for finely detailed work.

The Strathmore 500 charcoal paper has a good tooth that holds charcoal well.

The Strathmore 400 drawing paper has an even grain that is especially good for pencil drawing.

Canson Mi-Teintes has a bold, pronounced pattern more suitable to charcoal drawing.

Light to dark transitions can be handled easily in pencil with Canson #35 charcoal paper.

Canson Ingres has a pronounced surface with thin horizontal impressions. The medium texture is excellent for both charcoal and pencil.

Transferring Your Drawing

An easy way to begin working on a complex composition is to start with thumbnail concepts on tracing paper. Thumbnails are small (1" x 1½" up to 3" x 5") drawings. You may come up with a satisfying concept in just two or three thumbnails. Or, you may end up with two dozen before you're satisfied. The point is that it takes very little time to document and change your ideas at this size. Once you've selected a concept that you're happy with, do a preliminary drawing on tracing paper at actual size. Stay loose with this drawing. When changes are needed, slip your preliminary drawing under a new sheet of tracing paper and redraw the images, making the needed adjustments.

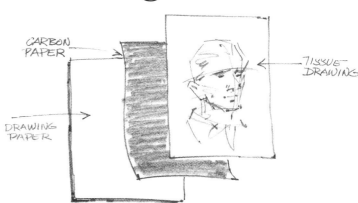

lightly erase some of the darker marks left on the drawing board or paper. Now you have a light drawing to work on to begin your final drawing.

MAKE YOUR OWN CARBON PAPER

When you are satisfied with your preliminary drawing, transfer this drawing to the final drawing paper. There are several ways to transfer artwork. If you are doing the final drawing on illustration board or a heavyweight paper, use a graphite paper sheet. You can make your own by taking a sheet of tracing paper and blackening it all over on one side with pencil.

TRACE YOUR DRAWING

Place your preliminary drawing on the final drawing paper or board, taking care to tape the top of the preliminary drawing to the board to prevent movement.

Next, slip the graphite paper (blackened side down) between the preliminary sketch and your drawing paper or board. Now all you have to do is carefully go over your drawing with a pencil using even pressure. During this tracing process, occasionally lift the carbon and tracing sheet to see how your lines are transferring. When you're finished tracing, remove the tracing paper and carbon paper and

USE A LIGHT BOX

Another transfer method you can use, when working on a thinner drawing paper, requires a light box. You can purchase a light box through most art supply stores. However, if you're handy, you can make one. Mine is a wooden box 17 inches wide, 17 inches deep, 6 inches high in front, and 9 inches in back. (The top of the box slants like a school desk.) Three fluorescent bulbs are mounted inside. The top of the box is white Plexiglas, which gives an even light over the top surface.

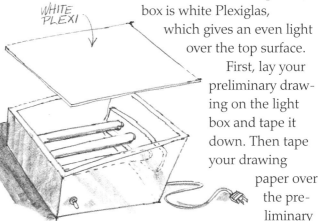

First, lay your preliminary drawing on the light box and tape it down. Then tape your drawing paper over the preliminary drawing. When the light in the box is on, you will see the preliminary drawing through the drawing paper, so you can simply trace the image with pencil on the drawing paper. For pieces too large for your light box, you can use a large window in your home.

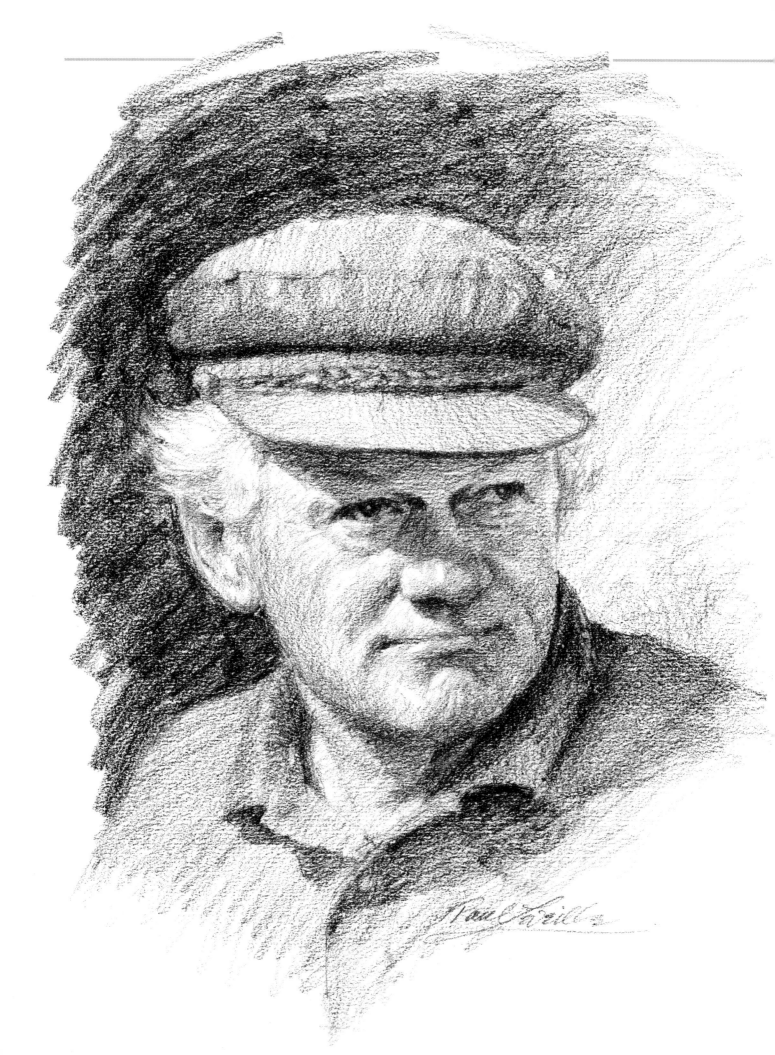

Head Proportions

I n this chapter, we will learn about measurements, proportions and locations of features commonly used for drawing the "ideal" head. Even though the placement of facial features and proportions may vary slightly from person to person, this information is useful when starting to draw a head from imagination or even when working from live models. When I work from a model or a photo, I start by lightly drawing the fundamental proportions in pencil or charcoal. Then I make adjustments as I go along by concentrating on what I see.

◄

THE FISHERMAN
Pencil on Canson
heavyweight drawing
paper.

*Canson drawing paper
has a strong texture that I
enjoy working on. With
2B, 4B and 6B pencils, I
rendered the subtle lights
and darks on the shadow
side of the face. The dark
background next to the
light side of the head helps
to push the head into the
foreground and contrasts
with the white hair.*

Skull

When tackling any project, it's always best to start at the beginning. The same advice goes for drawing the head. Although there are millions of different faces in the world, they all have the same basic structure—the skull. By studying and drawing the skull, you will gain an invaluable understanding of how the head and its features relate to one another. If you are going to draw heads, an important piece of equipment for your studio is a model skull. You can purchase one at a hobby shop or toy store, or through a scientific store or catalog.

Try sketching the skull in various positions as I have on these pages. With practice, you will soon be able to draw the skull from memory.

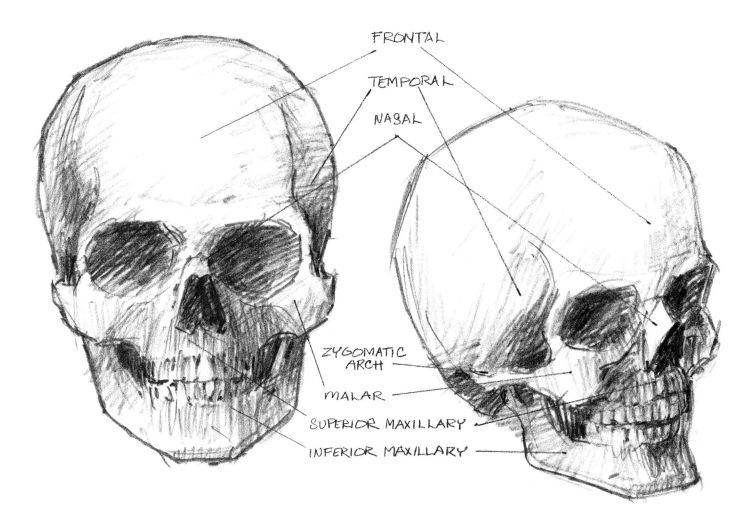

Notice how the temple area recedes on the sides of the brow bone. In this frontal view you also can see the egg shape of the overall skull.

In this drawing the structures of the cheek and brow bones that protect the eye are visible.

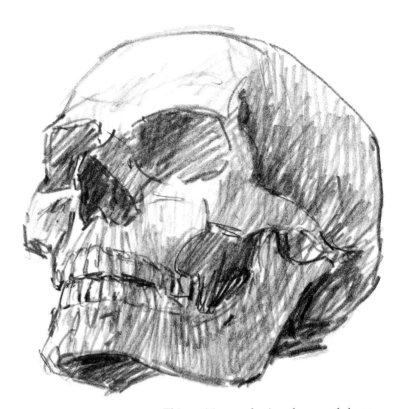

The bridge of the nose is composed of bone. The lower part of the nose is not visible here because it is composed of cartilage.

This position emphasizes the curved shape of the mouth area. The area between the nose and chin, including the teeth, has a curved, barrel shape.

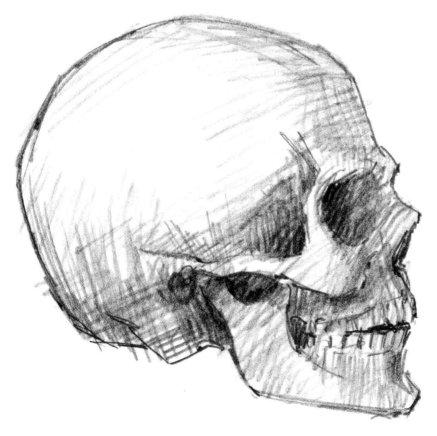

Planes

The structure of the human head can be simplified by eliminating details and breaking down the many shapes into a few basic planes.

Practice drawing these heads, or better yet, try working from a planed plaster (or plastic) cast. Once you feel more familiar with the head, then start drawing from a live model.

Whether you are working from a cast or a live model, it's important to use one main light source to accentuate the planes. In these drawings, the light source is above and to the left of the head. This lighting defines the features best by leaving shadow areas under the eyebrows, the nose, the upper lip and the chin. This is one of the most desired lighting situations for portraits since it reveals the forms of the features most effectively.

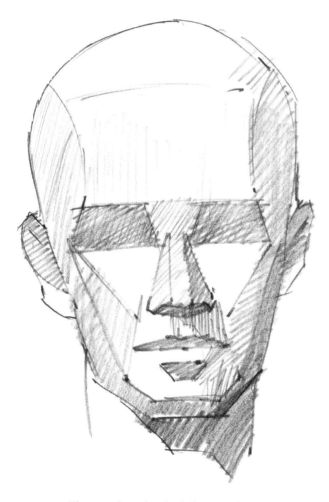

The area from the cheek down to the jaw is divided into three basic planes:

Light, where the light source is brightest;

Darker, as the form starts to turn from the light;

Darkest, as the form turns farthest from the light

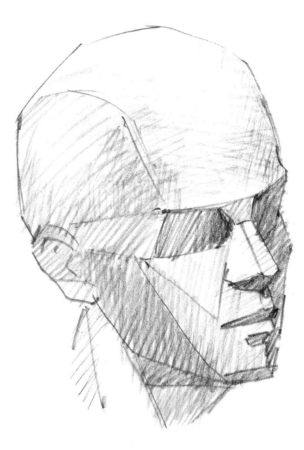

The way light is revealed on the planes of the head tells us how the head is shaped. Here, the jaw is dark because it turns back, away from the light. On the other hand, the ear is much lighter because it turns out from the jaw and catches the light.

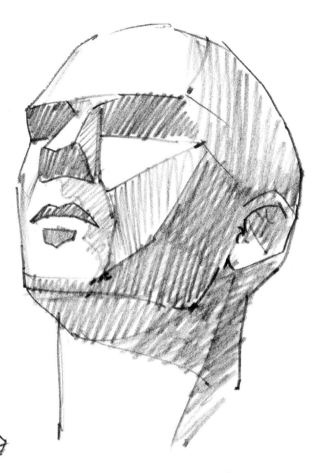

Try drawing the head in simple planes in a variety of positions. Remember to eliminate details. In this pose, eyes, eyebrows, nostrils, etc., have not been indicated.

The top and the back of the head have the same appearance that a ball lit from above would have. Starting from the top of the head—the brightest area—the head gets progressively darker as the planes turn from the light to the back of the head. This produces the look of a rounded structure.

The Head and Features

From the simplified planes of the head, we now progress to the study of the head and facial features. At this time, I would like you to squint at these drawings. Squinting allows you to eliminate the details of the features and see only the big shapes—the planes. When you're drawing the head, always start with the big planes, then proceed to the smaller shapes and features, and finally to the details.

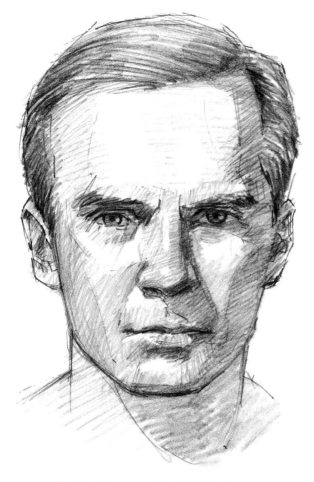

The big planes are still visible but they are softer. For example, the transition from light to dark on the cheeks is more subtle. The eyes stay back in the shadow plane under the brows and are not as light as the forehead and cheek areas. The only bright light is the highlight.

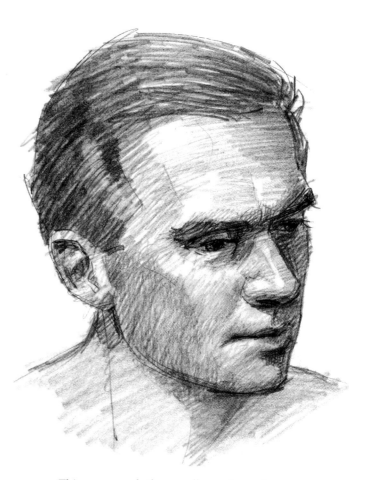

This pose reveals the overall roundness of the head. The brightest areas appear on the model's right forehead, the hair above the cheek, and the mouth area below the nose. As the forms turn away from the light they get darker.

This pose lets us see what happens on the shadow side of the head. A lot of the planes are defined by reflected light. For example, the ear is entirely in shadow, but because it's turned at a slight angle to the head, it is picking up more reflected light. Keep in mind that even though the ear is lighter than the planes around it, it is still in shadow and therefore darker than features on the light side of the face.

We've seen the subtle changes in planes on the cheeks. This pose reveals the dark planes caused by the canopy effect of the eyebrows, nose and jaw.

Adult Head Proportions

All adult heads look different and yet they all have similarities, such as two eyes, two ears, a nose and a mouth. These similarities allow you to use the following basic proportions in drawing the head.

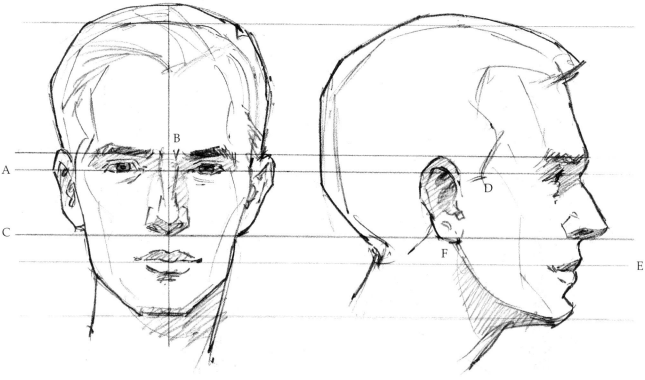

A: From the top of the head to the chin, the eyes are positioned approximately in the middle.

B: The eyes are about one eye-width apart.

C: The bottom of the nose is halfway between the eyebrows and the chin.

D: The ears are positioned between the horizontal lines of the eyebrows and nose.

E: The mouth is placed between the nose and chin, about two-thirds of the way up from the chin.

F: On the profile, notice that the ear is placed behind the vertical center line.

DRAWING A TILTED HEAD

One way to help determine the tilt of a model's head is to imagine that the model has a clear bucket over his head. The cylindrical shape of a bucket is very similar to the shape of a head. If a model put a bucket over his head and tilted his head back, we could see into the open part of the bucket. In fact we would see the elliptical shape of the rim of the bucket. This same elliptical line can be used for the feature guidelines for the eyes, nose and mouth.

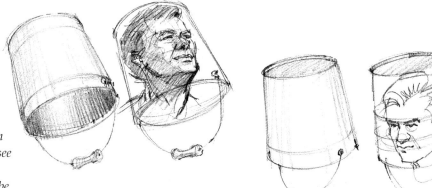

DEMONSTRATION 1
STUDY OF A MAN

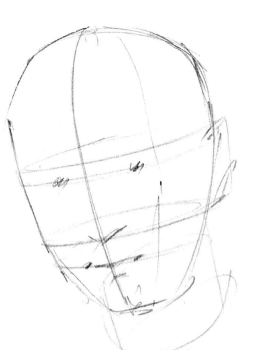

1 INDICATE THE FEATURE GUIDELINES

When you start to draw a head, loosely sketch the overall shape. In this case it is egg shaped.

Draw in the horizontal guideline for the eyes about halfway between the top of the head and the chin. Make this line an ellipse as though it were drawn around the outside of the egg. Do the same thing about halfway between the eyes and chin where the base of the nose will fall. Draw another ellipse about one-third down from the nose in the space between the nose and chin. Draw a fourth ellipse a little above the eyes. The eyebrows will fall on this line and it will help in positioning the top of the ear.

Finally, draw in the vertical ellipse that will represent the center of the face. Once again, draw this ellipse around the outside of the egg shape.

2 ADD THE LARGE DARK SHAPES

Now squint at the model and sketch in the large dark planes indicated by shadow and by the hair. Use the side of your pencil to block in these areas quickly and loosely. Don't bear down on your pencil too much at this stage. Keep a light touch—you may want to make adjustments by erasing.

3 REFINE THE FEATURES

Once you have the big dark areas in place, start to refine the features. For example, try to draw the upward shape of the eyebrows. Then indicate the different tones within the eyebrows. They usually get darker just above the eye and lighter at either end. Remember to work from large shapes to small.

DEMONSTRATION 2

STUDY OF A WOMAN

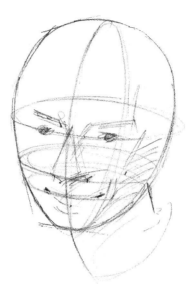

1 **INDICATE THE FEATURE GUIDELINES**
Draw in the overall shape of the head, then indicate the tilt of the head by drawing in the horizontal ellipse that the eyes will be on. Remember to draw the ellipse all around the outside of the egg shape. Since this model's head is tilted down, we see more of the top of her head. Imagine that she has a clear bucket over her head (see page 28). In this pose you would be able to see the ellipse that forms the bottom of the bucket. Use the same elliptical shape to draw in the feature guidelines for the eyebrows, nose and mouth.

Draw in the vertical elliptical guideline that will represent the center of the face. The bridge and base of the nose as well as the center of the lips will fall on this line.

2 **ADD THE LARGE DARK SHAPES**
Look for the largest dark shapes. In this case they are the model's dark hair and the shadows under the brows, alongside and under the nose, and on the left side of the face. Don't try to draw all the different shades of gray in these dark shapes. Keep it simple. Combine all the grays into one shape. Later you can start to define the subtle differences in tones.

3 **REFINE THE FEATURES**
By varying the pressure on your pencil you can make darker or lighter marks. Use this technique when moving from the dark tones to the lighter tone. The cheek on the shadow side of this face is a good example. To achieve the look of roundness there should be a subtle change in tone as the dark shadow area turns into the light on the top of the cheek. This can be achieved by using heavier pressure on your pencil in the shadow area and then letting up on that pressure, making lighter lines as you move to the light side of the cheek.

Since you have indicated the large planes it will be easier to draw the features accurately. For example, you have already indicated the position of the eyes with the elliptical guideline, and the large dark planes under the brows further define their position. Now it's a matter of drawing the shapes of the upper and lower lids and, finally, the eyeball.

DEMONSTRATION 3

STUDY OF AN OLDER MAN

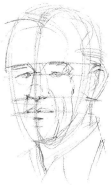
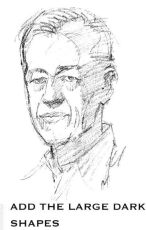
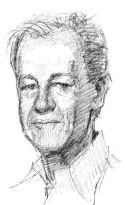

1 INDICATE THE FEATURE GUIDELINES
Again, start by sketching an egg shape. Draw the halfway feature line that the eyes will be on. The head is turned a little, so the vertical halfway line won't be in the center of the egg shape. It will be to one side. The bridge of the nose (between the eyes), the base of the nose, and the center of the lips will be intersected by this vertical line.

2 ADD THE LARGE DARK SHAPES
Squint and look for the big patterns of light and dark. Draw in the shadow areas on the side of the head and nose as well as under the chin. Notice the darker areas of the upper lip, under the lower lip and under the eyes. Draw in the hair lightly.

3 REFINE THE FEATURES
Now that shadows and features are in approximate position, start to draw the various tones between the light and shadow areas. Notice that the chin at its lightest area still has a tone. It is not white like the forehead. That's because of the egg shape. The light hits the top of the egg and as the egg shape curves down and back it receives less light.

DEMONSTRATION 4

STUDY OF AN ELDERLY WOMAN

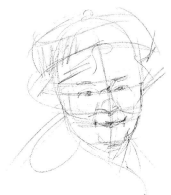
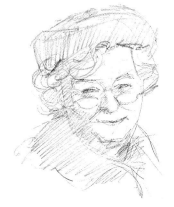
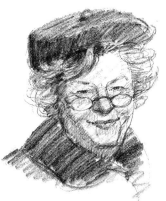

1 INDICATE THE FEATURE GUIDELINES
Use an egg shape to draw the basic outline of the head, but notice that the egg shape is not narrow at the bottom but fuller. There is a slight tilt to the head, so the model's eyes are not on a level plane, but are tilted. Draw the horizontal halfway line at the same tilt as the eyes.

2 ADD THE LARGE DARK SHAPES
Look for the big dark shapes. They are the hat, the shadow along the side of the head and nose, and the coat. Draw them in loosely and not too dark at this time. Remove the feature guidelines with a kneaded eraser.

3 REFINE THE FEATURES
Draw in the features by working from large shapes down to details. Start the lips, for example, by drawing both lips as one shape, then divide that shape in two. The upper lip, which is in shadow, is a long dark shape while the lower lip is a lighter shape. However, the bottom of the lower lip gets darker as it turns down away from the light.

Children's Head Proportions

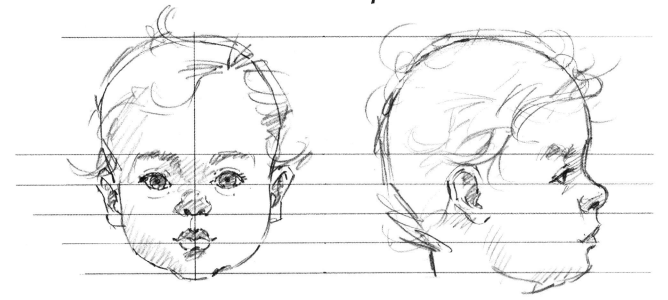

BABY

The eyebrows of a baby fall on the halfway line between the top of the head and the bottom of the chin. If you draw horizontal lines to divide the space between the eyebrows and chin into four equal parts, the eyes rest on the second line below the eyebrows, the nose ends at the third line, and the lower lip rests on the fourth line. Note that the eyes are a little more than one eye-width apart. The top of the ear falls between the eye and eyebrow lines. The bottom sits a little above the upper lip and below the nose.

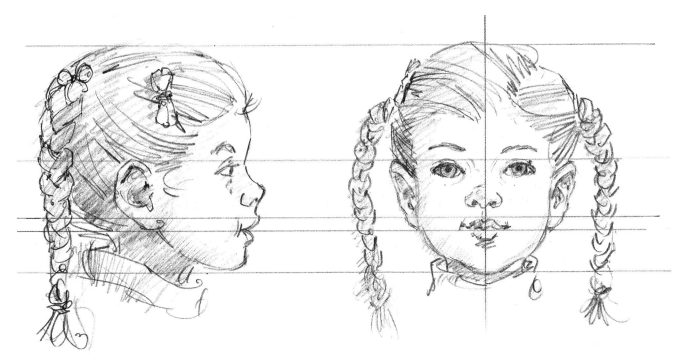

3-YEAR-OLD CHILD

The horizontal halfway line falls slightly above the upper edge of the eyelids. The horizontal line running midway between the halfway line and the chin falls between the nose and upper lip. The ears are located between these two lines, but extend slightly below the upper lip. The bottom of the upper lip rests on the same line that the lower ear does.

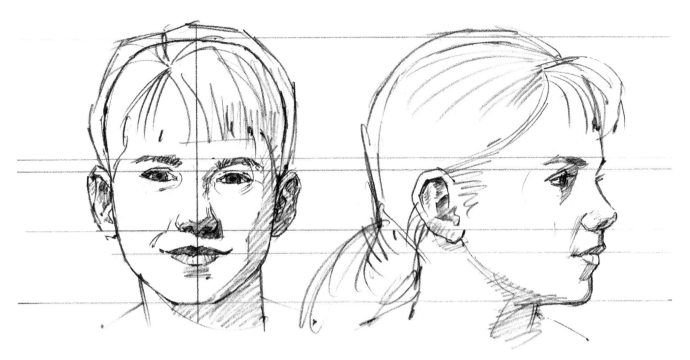

8-YEAR-OLD CHILD

The eyes fall below the halfway mark. The nose is located halfway between the eyebrows and the chin. Lips are between the nose and chin about two-thirds of the way up from the chin. Ears start roughly at the eye line and end below the nose line.

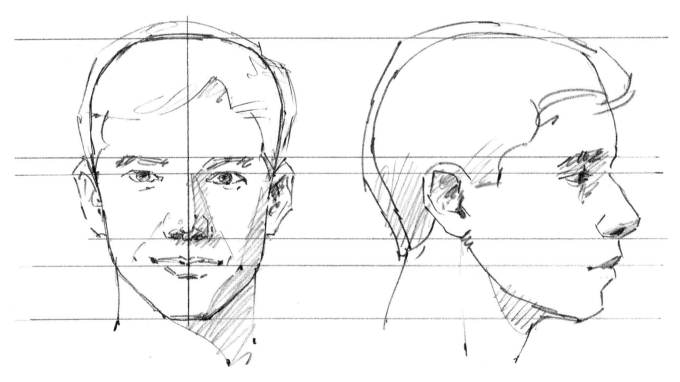

TEENAGER (AGE 14-15)

Eyes are positioned roughly below the halfway line. The bottom of the nose falls halfway between the eyebrows and the chin. The bottoms of the ears start at the bottom of the nose. The tops are roughly at the eyebrow line. Lips are between the nose and chin about two-thirds of the way up from the chin.

DEMONSTRATION 5

DRAWING A BABY'S HEAD

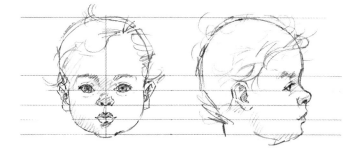

1 **INDICATE THE OVERALL SHAPE**
Knowing that the feature guideline that falls above the ears also runs above the upper edge of the eyelids, will help in positioning the features in this study. The addition of the vertical center line will position the tilt of the head.

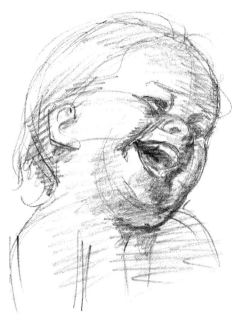

2 **ADD THE LARGE DARK SHAPES**
Continue to loosely define the features. Once you feel comfortable with the position of the features, you can erase the guidelines. Squint and lightly draw in the big shadow patterns. Keep things simple.

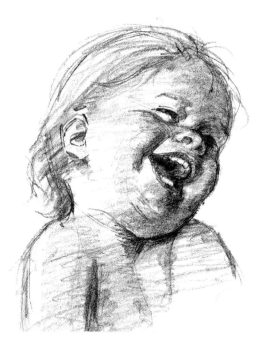

3 **REFINE THE DRAWING**
Continue to refine the dark areas. Pull out the light areas on the eyelids, cheeks, and side of the mouth with a kneaded eraser.

DEMONSTRATION 6

DRAWING A 3-YEAR-OLD CHILD

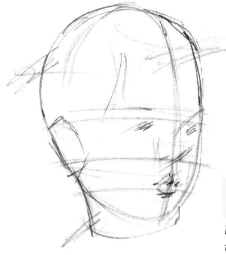

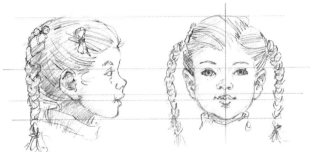

1 INDICATE THE OVERALL SHAPE

Usually a child's head is shaped more like a rounded egg than the elongated egg shape of an adult's head. All the child's features are located below the halfway mark of the head. The lower section is narrow while the upper section is larger and rounded like a ball.

This young model is viewed from below. To better see this perspective, think of the clear bucket over her head. You should be able to see into the bucket a little. The head is also tilted to its left.

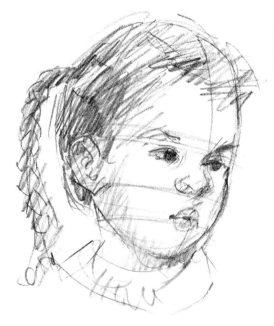

2 ADD THE LARGE DARK SHAPES

Once you have the features loosely in position, squint to find the largest dark shapes. They are the hair, including the braid, and the shadows under the left brow, alongside and under the nose, and under the chin. Sketch these areas in lightly, along with the light shadow area at the outside of the model's right cheek. Draw the basic shape of the features, but don't get too detailed at this time.

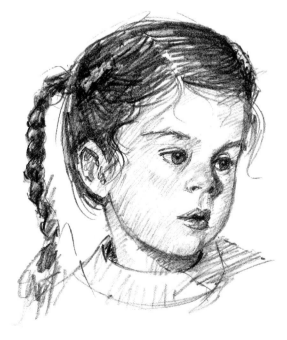

3 REFINE THE DRAWING

Now start refining your drawing. Let's take the model's right eye as an example. You've already drawn the almond shape and a dark area for the eye. Draw in the two lines above the eye that represent the lid. Lighten the white area of the eye with your kneaded eraser. Don't make it bright white; there is still a light tone of gray in that area. Next draw in the pupil very dark. Press the point of your kneaded eraser into the edge of the pupil to lift out a highlight.

DEMONSTRATION 7

DRAWING AN 8-YEAR-OLD CHILD

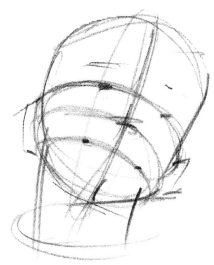

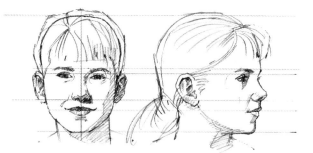

 INDICATE THE OVERALL SHAPE
Due to the "worm's-eye view" perspective, the overall shape of this head becomes more rectangular than egglike. Draw in the feature guidelines. Notice how the ears fall far below the eyes.

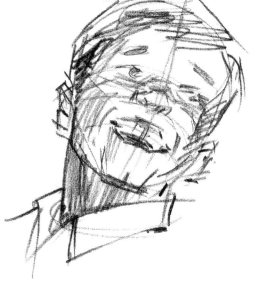

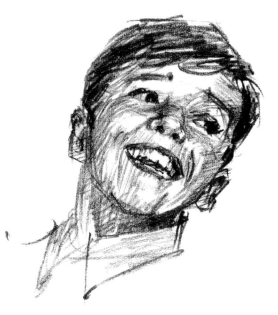

3 **REFINE THE DRAWING**
Continue working from the largest shapes down to the smallest. Save the detail work for the end. With the knowledge of the basic construction of the head, from the skull through the planes and approximate positions of features, and with practice, you will be able to draw faces in any position.

 ADD THE LARGE DARK SHAPES
Once again look for the large dark areas—the hair and under the chin. Try to maintain the tilt of the head. Keep your guidelines in the drawing until you are satisfied with the position of the features.

DEMONSTRATION 8
DRAWING A TEENAGER

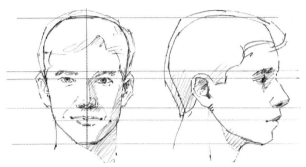

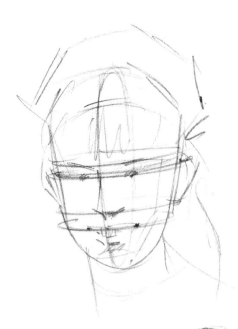

1 INDICATE THE OVERALL SHAPE

Start by loosely drawing the outer egg shape of the head. Also indicate the outline of the hair and bow. Draw in the horizontal elliptical feature guideline for the eyes. It falls halfway between the top of the head and the chin. Remember to draw it completely around the outside of the egg. Once again the model's head is tilted down so we should be able to see the elliptical shape of the bottom of the clear bucket.

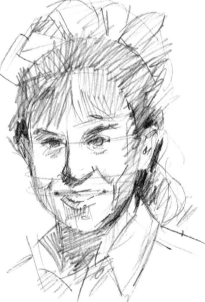

2 ADD THE LARGE DARK SHAPES

Squint at the model to eliminate details and determine the overall form of the dark shapes. The dark areas on this model are the hair and the shadows under the brows, including the eye socket, as well as the shadows on the sides of the face, alongside and under the nose, under the lower lip and on the neck. Sketch them in lightly, striving to capture the correct shapes.

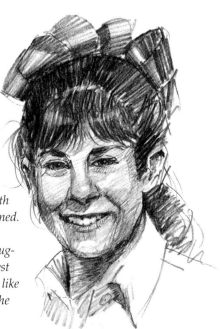

3 REFINE THE DRAWING

Begin refining the drawing slowly, once again starting with the largest shapes. The hair, for example, should be darkened. Keep your strokes going in the direction that the hair is combed.

Notice in the smile that each tooth is not completely drawn but suggested by adding darks under the teeth and on top. The darks suggest the shapes of the teeth. Because the mouth and teeth area is shaped like a barrel, part of the area is in light while the rest turns away into the shadow area.

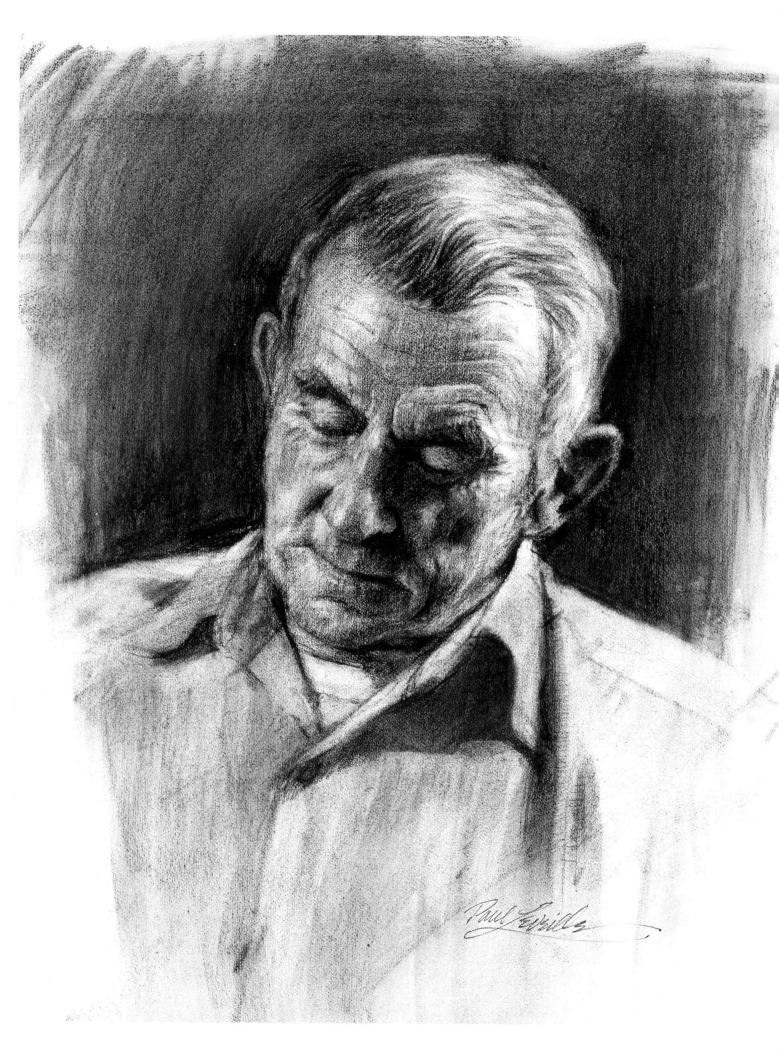

Drawing the Features

The features are what make human faces so interesting. Although most features are constructed similarly, each one still exhibits subtle differences. For example, each nose has a bridge followed by cartilage and two nostrils, but some noses are thin, while others are broad or turned up or hooked.

In this chapter we will see the basic construction of each facial feature and what to look for to draw them. We will also take a look at the chin and the neck, because portraiture doesn't stop with the mouth. Most portraits include at least some of the collar area, and the tilt of the head on the neck contributes much to the expressiveness of the portrait.

◄

WHITTLING
Vine charcoal and compressed charcoal on Canson charcoal paper.

At first it may appear that the model is sleeping. However, after closer observation, I think you will realize that his head would drop more if asleep. Actually he was whittling. Notice that as the head tilts down, the ears rise. I started this drawing with vine charcoal and put in the final darks with compressed charcoal.

The Eye

When you have a conversation with a person, what do you look at? Most likely the person's eyes. Sometimes people say more through their eyes than by their words. The eyes reveal moods and personalities, such as happiness, sadness, alertness, tiredness, nervousness, fear, surprise and slyness.

Before you attempt to translate expressions and moods through the eyes in your drawings, you need to understand how the eyes function in the head. The eyeballs sit in the sockets of the skull. They can rotate left, right, up and down. The movement of muscles and skin around the eyeballs is what actually reveals expressions. The following illustrations describe how the eye appears when in different positions.

When looking to one side or the other, the skin and muscles around the eyes form a teardrop shape.

In profile, the iris appears as a narrow elliptical disk. Notice how far the eye is set back from the bridge of the nose.

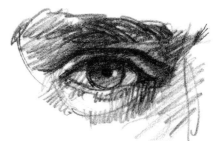

The eyelid is open and has folded up under the brow. Can you see the shadow that the upper eyelid casts on the upper part of the eyeball?

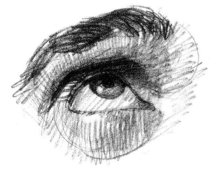

When the eye looks up, the eyelid folds even more under the brow and more of the white of the eye shows under the iris. The iris appears more elliptical than round in this position.

The upper lid of the eye stretches upward toward the nose and fore-head, while the lower lid drops toward the outer side of the face.

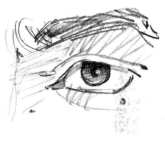

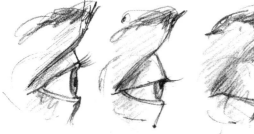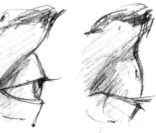

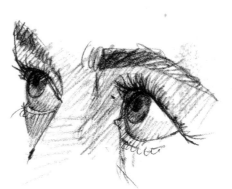

When the eyelids are closed, the upper lid curves smoothly over the eyeball. As the eye opens, the upper lid starts to fold under the brow. The lids have thickness and protrude slightly from the eye.

When the eyes look up, the upper lid disappears under the brow. In this three-quarter view, the eyelids form a teardrop shape.

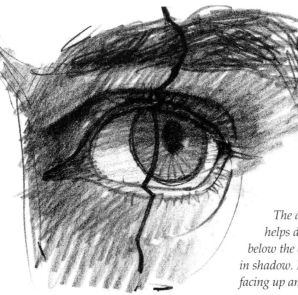

The dark line running through the eye area helps define the structure. Notice how the area below the eyebrow recedes. This area is very often in shadow. In contrast, the shelf of the lower lid is facing up and usually is very light.

The Nose

One of the most distinctive features of the human head is the nose. It protrudes more than any other feature and gives the face depth and character. Although the variety of nose shapes seems endless, all noses have the same basic triangular form: narrow at the top and wider and fuller at the bottom.

The upper part of the nose (the bridge) is formed by bone. The lower part consists of five pieces of cartilage: Two make up the tip, two make up the wings of the nostrils, and one divides the nostrils.

The skin lies smoothly over the bone of the upper nose, usually catching a highlight.

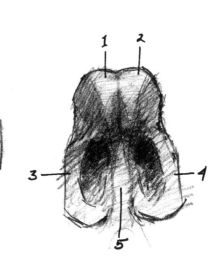

Seen from below, the five pieces of cartilage that make up the lower part of the nose are apparent.

Drawing the nose at different and unusual angles will help you understand its shape.

The nostrils are closer together toward the tip of the nose and get farther apart toward the face.

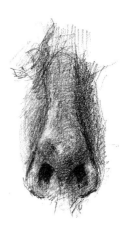

Highlights on the tip of the nose will make it appear to come forward.

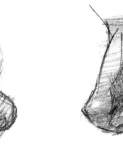

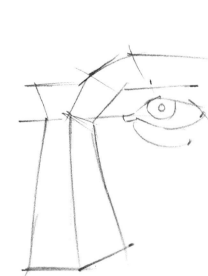
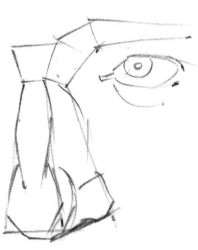
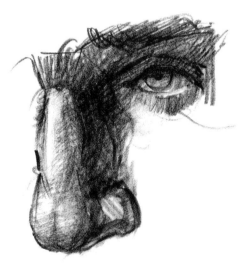

This is just a small sampling of the variety of nose shapes. However, all are basically thin and narrow at the bridge and get fuller at the bottom. Some even have a ball or bulb shape at the bottom.

1 **SIMPLIFY**
When first drawing the nose, simplify it into a wedge-shaped series of planes.

2 **DEFINE SHAPES**
To define the subtle shapes of bone and cartilage within the wedge shapes, start to draw the rounded forms of the bridge, tip of the nose and nostrils. Notice how the bridge tapers into the bulb part of the nose.

3 **ADD LIGHTS AND DARKS**
Continue by rendering the light and dark areas. Save the white of your paper for the highlights, or lift them out with an eraser.

The Mouth

The face's most animated feature is the mouth, which is constantly changing with every mood and expression. The lips derive a good deal of their shape from the teeth and bone that they wrap around. The next time you see a person smile with his lips parted, notice how the upper lip gets its shape as it is stretched across the teeth. In the drawing at left, the upper lip slims as it is pulled back across the teeth in a smile.

Although it's best to consider the upper and lower lip as one when drawing them, each is shaped differently. The upper lip consists of three shapes and has a steeper slant inward toward the teeth. The lower lip has two shapes and is usually fuller than the upper lip.

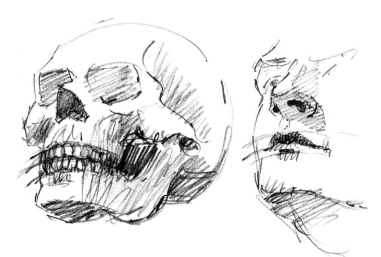

The skeletal shape of the closed mouth is similar to a barrel. Hold this thought when drawing the lips.

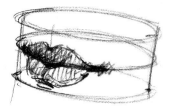

Using the cylinder or barrel shape helps when drawing the lips at different angles.

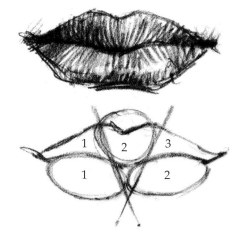

The upper lip has three shapes and the lower has two.

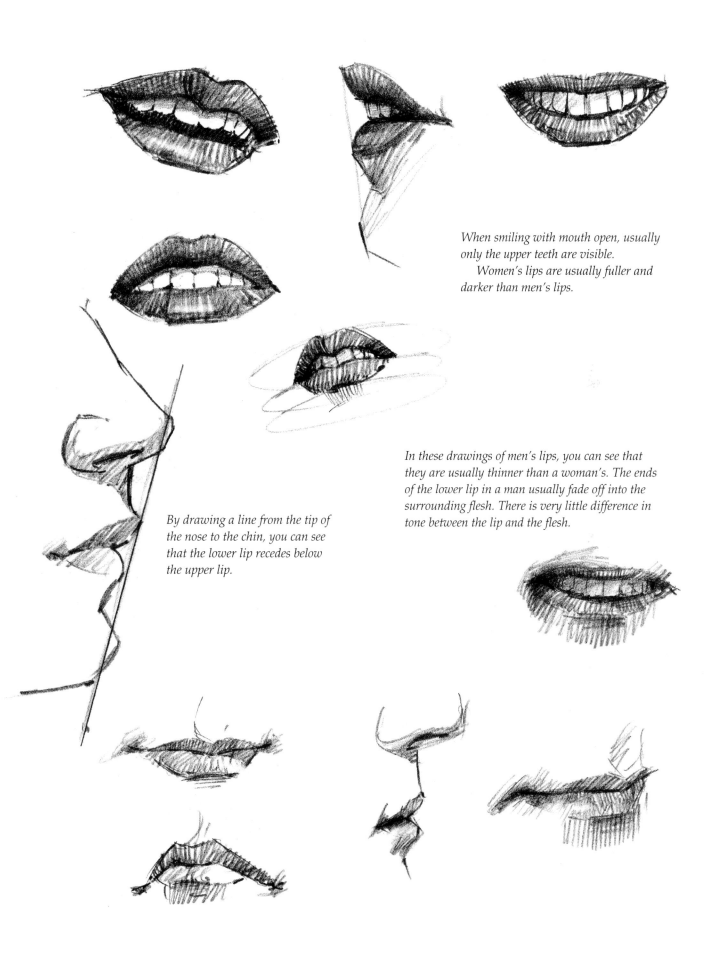

When smiling with mouth open, usually only the upper teeth are visible.
 Women's lips are usually fuller and darker than men's lips.

In these drawings of men's lips, you can see that they are usually thinner than a woman's. The ends of the lower lip in a man usually fade off into the surrounding flesh. There is very little difference in tone between the lip and the flesh.

By drawing a line from the tip of the nose to the chin, you can see that the lower lip recedes below the upper lip.

The Ear

With all the swirls, dips and folds that can be seen in an ear, drawing one may appear difficult. However, when you study the ear you will see that by simplifying the shapes, drawing the ear becomes easier.

The ear is made up of cartilage and ends at the bottom in a soft fleshy lobe. The center is a bowl shape. On a profile, the top of the ear is in line with the eyebrow and the bottom lines up with the base of the nose. The front of the ear is situated on the halfway line between the front and back of the head. The back of the ear has a slant similar to the slant of the nose. As with all features, the ears change greatly from person to person, but the basic overall shape and folds of the ear are similar.

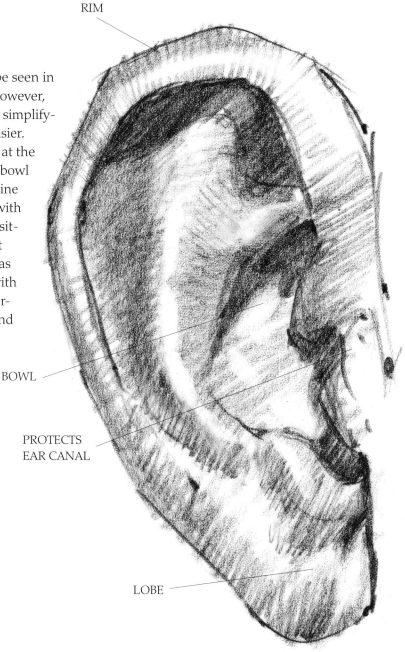

RIM

BOWL

PROTECTS
EAR CANAL

LOBE

The largest, most noticeable structures of the ear are the lobe, the bowl and the rim. When drawing the ear, look for individual characteristics in these structures. For example, some earlobes are long and fleshy, while others attach to the side of the head.

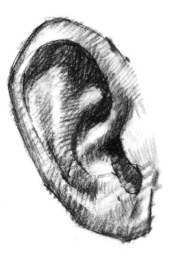
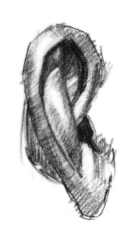

When looking at the head in pro-file, we can see the inner bowl and other shapes that make up the ear.

As we view the ear from the back three-quarter view, the outer bowl starts to appear. This is the same cartilage that attaches the outer ear to the head.

As we view the ear from behind, we can see the outer bowl as it meets the head.

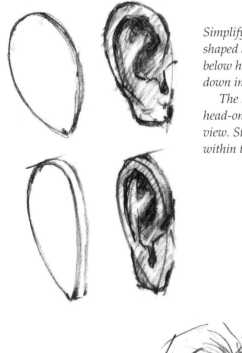

Simplify by first drawing the ear as an elliptical, teardrop-shaped disk. Once the disk is drawn, sketch the bowl a little below halfway on the disk. Proceed to the rim and let it flow down into the bowl.

The lower drawing shows the ear as you look at the model head-on. Here the disk becomes more elliptical as it turns from view. Start drawing as before and keep all parts of the ear within the disk shape.

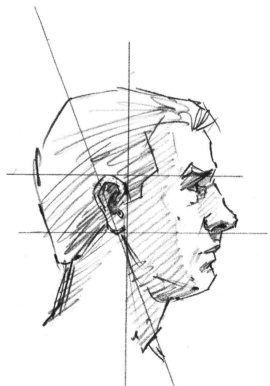

The ears follow the angle of the head and are usually close to the head. In the profile view, the front of the ear is situated on the halfway line between the frontal plane of the face (not in-cluding the nose) and the back of the head.

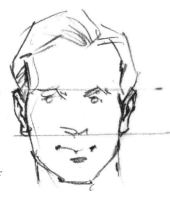

The Chin

Below the mouth protrudes a bulb-shaped area of muscle called the chin. The top of the chin goes back into a recessed area under the lower lip. The bottom center of the chin very often has an indentation or cleft.

As with all features, the chin changes in appearance from person to person, from a protruding chin to a receding chin or a "double" chin.

The muscle and skin of the chin pad the front of the jaw.

When the mouth is open, the muscle and skin of the chin tighten and flatten.

Between the lower lip and the chin is a recess that is often in shadow.

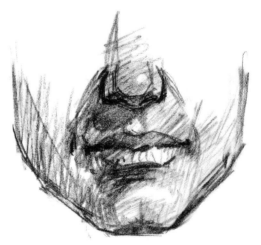

From the front you can see the ball shape of the chin. The light is hitting the top of this ball. The chin gets darker as it turns down and away from the light. The cleft at the bottom of the chin is achieved by shading with your pencil progressively darker up to the center of the cleft.

The Neck

The neck, with its long, flexible muscles, provides support and mobility for the head, allowing it to turn left, right, up or down.

In front, on both sides of the neck, are the sternomastoid muscles that run from and in back of the ears, down to a narrow meeting point at the center of the collar bones. The protrusion commonly known as the Adam's apple is located between these muscles. In the back, the head is supported by the powerful trapezius muscles that slope down from the base of the skull to the back and shoulders.

When drawing from a model, try capturing the many different moods created by a tilt of the head or a raising of the chin. All these movements are derived from the neck.

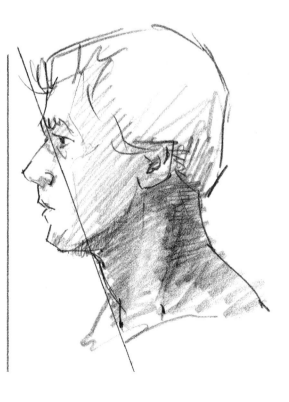

The sternomastoid muscles come from the skull at the back of the ears down to a meeting point at the center of the collar bones. These muscles are more pronounced in a man than in a woman.

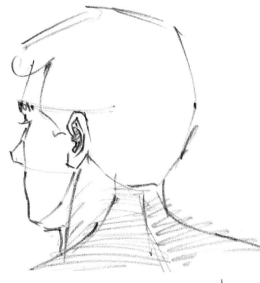

In the back, the trapezius muscles come down from the base of the skull to the shoulders and back. These muscles support the head.

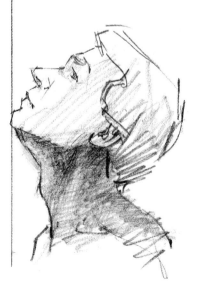

The neck does not come straight down from under the head. It tapers back even when the head is tilted up and back.

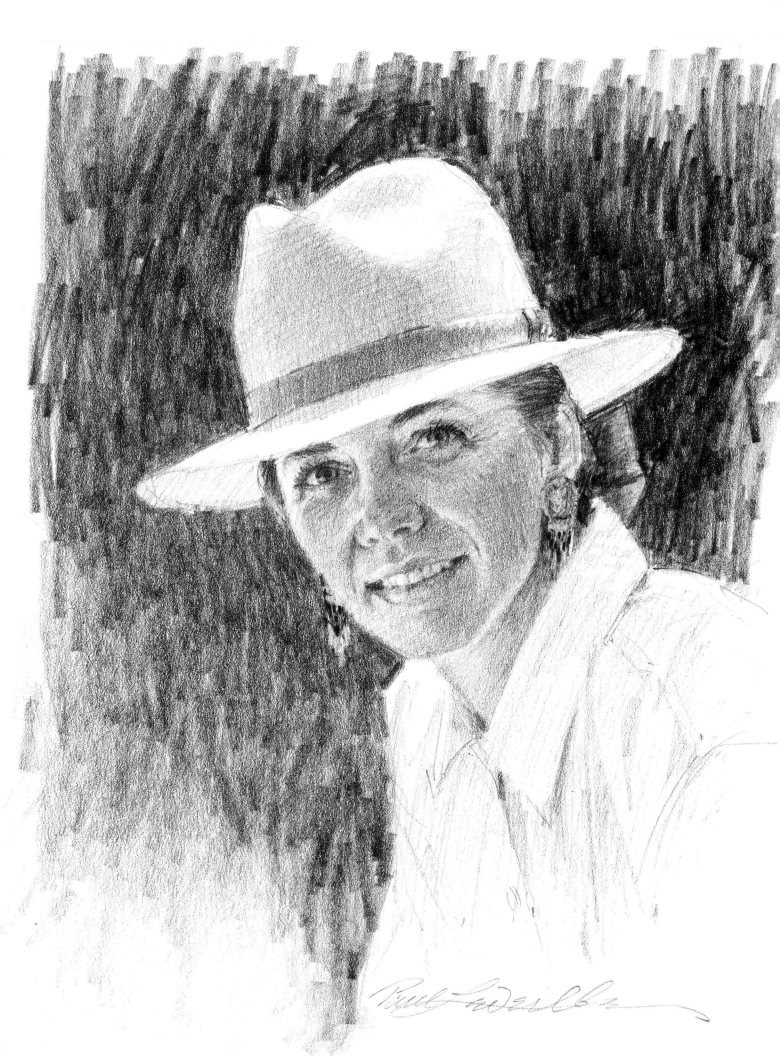

Values

The various shades of dark and light that we see on a model and in our drawings are commonly referred to as values. Values are the most important aspect of charcoal and pencil portraits, or of any portrait for that matter. When drawing, we are working on a two-dimensional surface and attempting to create the illusion of a three-dimensional head. Through the use of dark and light values, we can create depth and weight and a feeling of solidity. To see this effect, draw a man holding two spheres that are the same size. Render one sphere in dark values, the other in a simple outline. Which, in your opinion, is the heavier sphere?

◄

PAT
2B and 4B pencil on
Canson drawing paper.

In this outdoor pencil por-
trait of my wife, the light
is coming from above and
behind her. Her face was
in shadow, but received a
good deal of reflected light
from a white reflector card
I set up on her shadow
side. Since most of her face
was in the middle value
range with little contrast, I
had to do a lot of squint-
ing to see and draw these
subtle lighter and darker
areas.

Creating a Three-Dimensional Look

Using values creates a three-dimensional appearance by revealing where light is and where it is not. When light is directed at one side of the head, only that side remains in light. The light can't go through the head because it is solid. So the other side is in shadow. Rendering light and shadow in a two-dimensional drawing gives us the sense of an object (the head) with mass and weight—a solid form.

Surface textures can be indicated by using values. Adding a highlight to a rendered round object, such as an apple, suggests a shiny surface. The folds in a soft cotton sweater have subtle variations in values from light to dark. They do not have highlights that would make the sweater's surface appear hard or shiny.

Values add weight to an object by suggesting depth and density. The line drawing of a head in a child's coloring book appears flat and weightless, but coloring it in with shades of dark and light (values) creates the illusion of solid form.

When you start a drawing, squint at the model. This tends to eliminate subtle values and lets you see only the biggest value shapes of dark and light. It's important to draw the big shapes correctly before moving on. Once you've drawn the shapes in their proper positions, then look for the next largest value shapes, and so on until you get to the finest details. This method works whether you're drawing landscapes, still lifes or portraits.

Through the rendering of dark, middle and light values, you can depict the illusion of a hard, transparent surface like glass.

The range of values from light to dark indicates a round, solid object. The highlight suggests it is a shiny object.

The texture of the book cover appears to be a matte surface. There are no highlights that would indicate a hard, shiny surface.

The shadow cast by the napkin suggests the curve of the book pages.

The reflected light on the underneath edge of the shadow side of the apple creates the feeling of roundness. This light is reflected by the white napkin the apple is resting on.

Which sphere is heavier? I think you will agree that the ball rendered in dark values gives the illusion of weight. The sphere that is clear appears to be weightless, like a bubble.

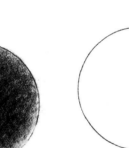

Above left is a simple square outline that has no weight or dimension. Rendering that square in values from dark to light creates the illusion of a cylinder.

Values can also turn a two-dimensional circle into a three-dimensional sphere.

To see if you are on target with your values when drawing the head, just turn your drawing upside down. Assuming that your light source is from above the head, you should be able to see your values descending from light at the forehead to darker values toward the chin.

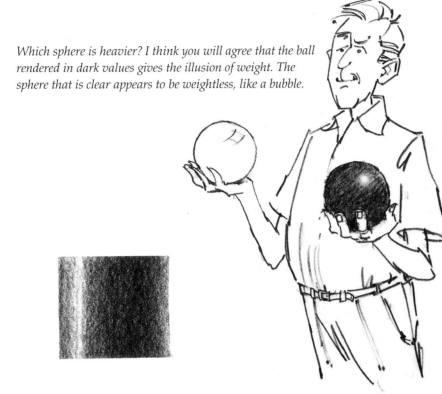

Using a Value Scale

Lightest Values
The light is coming from slightly above and to the model's right. The forehead receives the most direct light and is therefore the area of lightest value.

Highlights
These bright spots are often found on round shiny surfaces such as eyes, end of the nose, teeth and jewelry.

Halftone
As the form of the cheek curves away from the light, it gets a little darker. Areas that are midway between the lightest values and the dark shadows are called halftones.

Cast Shadow
Here the chin blocks the light, causing a cast shadow on the neck.

Turn this book upside down and look at this drawing. Can you see the value progression from light to dark from the forehead down to the chin?

A value scale can be a great help in drawing correct values. A value scale simplifies the many possible values into just ten values. Values range from black, through grays that get lighter, until they reach the lightest possible value, white.

MAKE YOUR OWN VALUE SCALE

You can make your own value scale. On a sheet of drawing paper measure down and mark ten one-inch-square boxes. Starting at the top use the side of your pencil point and move it rapidly, back and forth over the boxes. As you move down the boxes add pressure to your pencil. The idea is to have a white box at the top slowly and evenly turning to black at the bottom.

By holding this value scale at arm's length in front of your model and squinting at it and the model, you can compare values on the model with those on the scale. Then you can hold the scale next to the drawing to help you duplicate the values that you see on the model.

Reflected Light
Very often the outside edge of a form on the shadow side of a face becomes lighter due to light reflected from a nearby surface or the sky. Because this reflected light contrasts with a dark shadow, it appears to be very light in value. However, it is never as light as the values on the light side of the head.

Lightest Value
Even though this is a low key drawing, there is a small area of bright light on the forehead.

Shadow
The bottom of the nose turns sharply away from the light and is in shadow.

Cast Shadow
Since the nose blocks the path of light, it casts a shadow above the upper lip.

Darkest Value
The dark jacket turns to the darkest value in this area because it receives no light at all.

This drawing is a good example of using simple value shapes. Squint and you will see large dark shapes under the brows. Open your eyes and you will see some of the details of the eyes appear within those dark areas.

COMPARE YOUR DRAWING TO THE VALUE SCALE

Use the value scale to double-check the values in your drawing. In the shadow areas there should not be any values as light as those in the light areas of the head. At first glance, a reflected light in the shadow area may seem very light. However, that is only because the reflected light is surrounded by dark shadows and seems light in comparison. Use your value scale to compare the values of the reflected light with the values on the light side of your model's head. You will find that the reflected light value is much darker than the values on the light side of the head.

HIGH KEY OR LOW KEY?

Depending on your model's complexion and hair coloring, and the lighting, your drawing may be "high key" or "low key." When the values are predominantly lighter (on the upper end of the value scale) your drawing is high key. In a low key portrait, the values fall mostly on the darker, or lower, end of the scale. Look at the two portraits on these two pages. Can you tell which is high key and which is low key?

Carving Shapes With Values

A portrait drawing should be approached the same way you would approach a sculpture. The sculptor starts with a large block of clay and begins the bust by finding the largest shapes first before starting with an eye or a nose. He tries to capture the basic overall shape of the head, looks for the big planes, and then suggests the features roughly.

When drawing a portrait you should start by sketching the overall head shape, most often like an egg. Next you should draw in the horizontal feature guidelines for the eyes, nose, mouth and ears. Then draw the big dark shapes or values of shadow that most often appear on the side of the head, under the brows, alongside and under the chin. You should not start on the details until all work on these big value areas is complete.

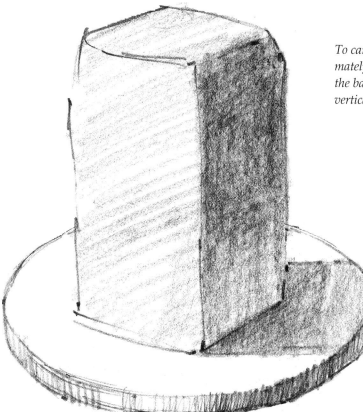

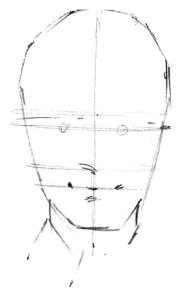

To carve a head, a sculptor starts with a block of clay approximately the size of a head. To draw a head, we start by drawing the basic overall shape of the head and adding horizontal and vertical feature guidelines.

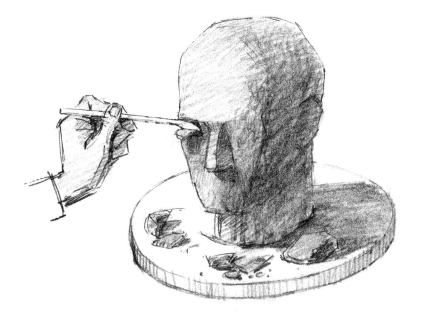

With drawing, as with sculpting, the artist must start with the big shapes first. The sculptor carves those shapes from clay while the pencil artist "carves" the shapes by drawing light and dark values. The eye area underneath the brows seems to recede because it is in shadow—a darker value. The tip of the nose appears to come forward because of the highlight—a light value.

The sculptor refines the large carved areas by carving and adding smaller pieces of clay. Finally the sculptor adds the details. Similarly, the pencil artist works from the large value areas to smaller value areas. In the second drawing the model's right cheek has been simplified into two values, one representing the shadow and one representing the light—simple big shapes. In the third drawing the cheek has a more rounded quality. More values between the dark shadow and light side have been used to accomplish this.

Expressions

T he human face is an endless source of interest for me. With all the millions of human beings on this earth, each one looks different, so how could I ever get bored? On top of that, each face has many muscle movements that result in dozens of different expressions. Just one face can express anguish, fear, joy, surprise and more. This chapter will explore how the various movements of facial muscles and features can create different expressions.

◄

LEN
Vine charcoal and compressed charcoal on Strathmore 400 drawing paper.

Soft vine charcoal was used to start the portrait. Vine charcoal can be removed easily with a kneaded eraser, which facilitates corrections. Once satisfied with the positions of the features and shapes, I proceeded with a darker, more adhering, stick of compressed charcoal. I achieved the halftones by rubbing charcoal on the paper with my finger. The highlights were pulled out with a kneaded eraser.

Happy

A happy expression involves much more than just the corners of the lips turning up. When the corners of the lips go back and up in a smile or laugh, the cheeks bulge also. Notice how the lower eyelid "scrunches up." The lower lid usually comes up and covers part of the iris. During a hearty laugh the lids may close almost completely over the eyes.

SO GLAD YOU COULD VISIT!
Over the years older people acquire facial creases that can add charm to their smiles.

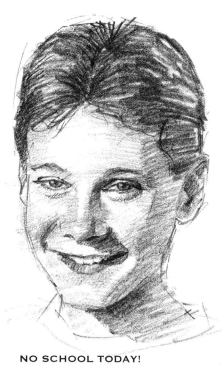

I LOVE MY BATH!
Even without the creases of age, you can see this baby's attitude through the wide smile, tight cheeks and partially closed eyelids.

NO SCHOOL TODAY!
This wide grin is accompanied by tightened cheek muscles. The lower parts of the irises are partially covered by the bulging lower lids.

GREAT JOKE!
In a hearty laugh such as this, the eyes almost disappear behind the lids. The head is thrown back, adding to this happy expression.

Angry

The corners of the lips usually are drawn down. The most revealing features are the eyebrows and upper lids of the eye. The eyebrows pull together and form strong folds over the bridge of the nose. The mouth may be open and frowning.

I HATE WHEN THAT HAPPENS!
The knitted brows and partially open mouth reveal a verbal venting of anger.

TRY ME!
This expression is dominated by the slanting eyebrows and the tightened muscles between them. The frown and the chin pushed forward add determination to this angry expression.

YOU HEARD ME!
The strongly knitted brows cause folds on the forehead. The open mouth with lips tightly drawn on the sides completes an expression of rage.

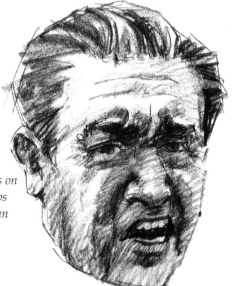

WHAT DID YOU SAY?!
The eyebrows are dropped down and the eyes are in a tight squint. The sneering mouth completes this expression of disdain and hate.

Surprised

Think back to the last time you were surprised about something. Was it a happy surprise? Or were you shocked? Or even scared? Each of these emotions has its own nuances or telling details in the movement of the facial muscles.

HAPPY SURPRISE

Eyes are often wide open but a portion of the lower lid may still cover the iris. An open mouth, turned up at the side, or a smile is evident. The eyebrows are raised.

FEARFUL SURPRISE

This expression usually has a wide-eyed stare (whites showing around the iris). However, the eyebrows are up and lips may be turned down at the sides or the mouth may be gaping.

SHOCKED SURPRISE

In this expression, the eyes are again wide open with a lot of the white showing. Eyebrows are pulled down in the center and up on the sides. The mouth may be drawn open wide with the sides down.

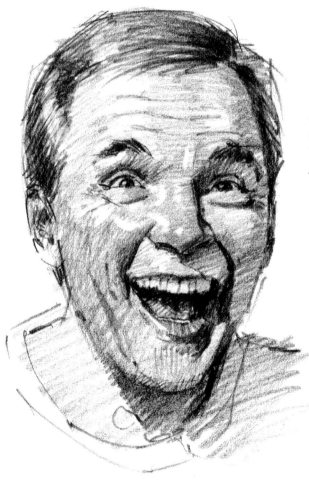

I WON!

The eyebrows are lifted, showing surprise, while the tightened muscles of the lower lids cover part of the eyes, revealing joy. The open mouth with lips stretched upward adds to the mood. Notice how the raised shoulders suggest that the head is coming forward, adding animation to the expression.

THEY'RE HERE!

In this pose the expression of surprise is revealed primarily through the wide open eyes and lifted brows. The mouth is neutral—not a smile, but not a frown.

WHO BROKE MY VASE?!

A combination of shock and anger are evident in this expression of surprise. The eyebrows slanting down toward the nose and the tightened muscles between the brows indicate anger. The wide-open eyes reveal shock. Even though the lower part of the iris is covered by the lower lid, the eyes don't appear happy because the muscles under the lower lids are not bulging. The sides of the upper lip are drawn down to form an unhappy expression.

TRIPLETS!

Surprise and shock are indicated in this face not only by the wide-open eyes but also by the eyebrows that subtly lift upward at the top of the nose. The slight frown adds to the look.

DID YOU HEAR SOMETHING?

A touch of fear shows up in this surprised expression. The lifted eyebrows, especially the model's left brow, depict concern. The wide-open eyes and gaping mouth with turned down lower lip combine to reveal surprise and fear. The rim lighting adds a feeling of mystery.

Thoughtful

A thoughtful expression is usually calm and the features seem relaxed. There are no lines in the forehead or around the eyes and sides of the mouth to indicate muscle movement. The eyes may appear fixed on something but are not squinting or open wide.

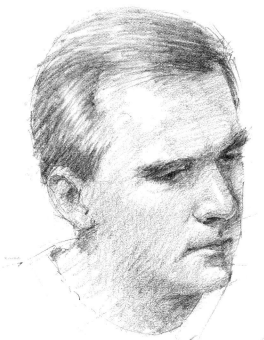

THINKING
The eyes are in a fixed position, gazing downward. The dip in the eyebrows gives a serious expression.

HAPPY THOUGHTS
Again the eyes are fixed, but looking upward. A slight bulging of the lower lid reveals a happy thought.

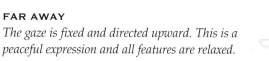

FAR AWAY
The gaze is fixed and directed upward. This is a peaceful expression and all features are relaxed.

Yawning

Eyes usually are closed tight, eyebrows are up,
mouth is open very wide. The chin gets tucked back
and forms folds in the neck.

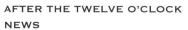

**AFTER THE TWELVE O'CLOCK
NEWS**
*This yawn is at its apex. The mouth is
stretched open to the limit. Notice the
wrinkles around the nose and between the
eyes, as the eyes are squeezed shut. Will
she make it from the recliner to bed?*

BEDTIME
*The eyes are closed tightly. The mouth is stretched
open while the chin is tucked in. Nighty-night.*

Sad/Crying

When faces are sad, the eyebrows tend to lift above the nose and pull the skin above the upper eyelids with them in the same upward direction.

When crying, the eyes are closed tight and the eyebrows head down. The mouth is open and the lips may be frowning.

THAT'S TERRIBLE!
Empathy emotes from this face. Most of the concerned and sad expression is evident in the uplifted eyebrows and skin above the eyes. The mouth has a slight frown.

WHERE'S MY BLANKY?
Pain or anger might be seen in this pose. The eyes are shut very tightly. The brows are knit and the open mouth with upper lip stretched downward calls for our attention.

WHAT NEXT!
The eyes in this face are focused as if thinking but the accompanying frowning mouth suggests unhappiness.

In Pain

The mental pain of anguish and despair shows in uplifted eyebrows above the nose, usually pulling the skin over the upper lids in the same direction. A subtle change may appear in the eyebrows of a person experiencing physical pain. In this case the eyebrows may lift but dip a little above the nose— almost a hint of anger.

HEADACHE WON'T QUIT!
Again, the skin over the eyes, brows and forehead all seem to be lifting up. The mouth is slightly open and frowning. Notice that the eyes are partially covered by the upper lid.

MY ACHING BACK!
Pain is reflected in the entire face, from the uplifted eyebrows that lift the skin above the eyes and cause the skin of the forehead to fold, to the lifted upper lip and wings of the nose.

OH NO!
Anguish and sorrow are depicted by raised eyebrows that also pull the skin above the upper eyelids with them. The frowning, slightly open mouth suggests a loss for words.

IT CAN'T BE!
A sense of hopelessness and anguish is revealed in this expression. Not only are the ends of the eyebrows lifted up over the nose, but the skin over the upper eyelids is also. The open-mouth frown completes the picture. Notice that the upper third of the iris is covered by the upper lid.

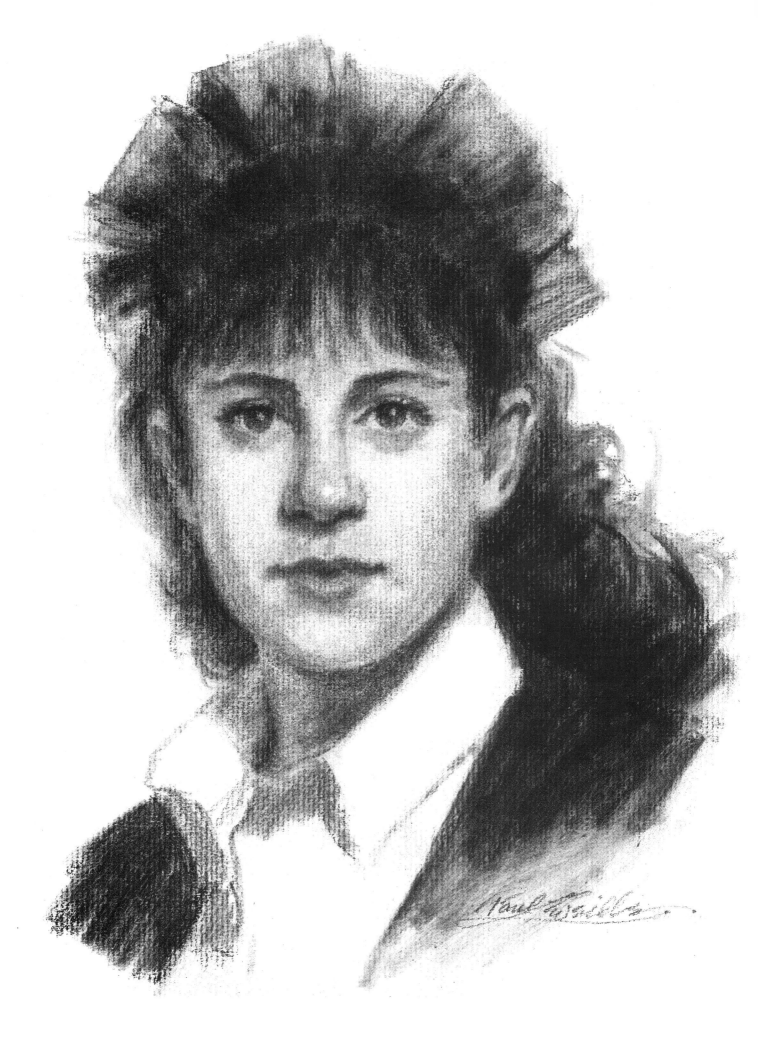

Working From a Model

I can't stress enough how important it is to work from a live model. In addition to helping you learn how and what to "see," working from life creates an adrenalin flow, an excitement and an immediacy that you don't get working from a photograph.

When you work with a live model, you can see the subtle value changes that occur in the shadow areas. Photographs show shadows as solid black areas with few if any changes in value.

On the other hand, photos can be a great aid in drawing portraits. As reference, they allow you to work when a model is not available or when it is more convenient for you. Photography can capture those elusive expressions that are difficult to catch when working from a model. The ideal situation is to work from both a model and photographs.

Whether you photograph or draw from a model, lighting is very important. When lighting a model remember to use one main light. This can be an inexpensive clip-on light with a shade that can be purchased in any hardware store. Art stores carry a similar but more expensive light with an attached tripod stand.

Use a 100 to 150 watt bulb for your main light source. A second light can be used to lighten up the shadow areas, but use a lower watt bulb or one set farther from the model so it won't be as bright as the main light. Later in this chapter you will see a variety of lighting arrangements you may want to try.

◀

GIRL WITH BOW
Vine charcoal and compressed charcoal on Strathmore 500 charcoal paper.

In this portrait, I started with a vine charcoal and finished with compressed charcoal to achieve rich darks. For a soft effect, I used a tortillion and stump in the darks as well as in the halftone areas. A kneaded eraser was used to lift out the light areas, including the highlights in the eyes and on the end of the nose.

Finding the Best Pose

Before you set up your model, ask yourself why this portrait is being done. Is it a commission, or are you doing it for yourself? If it is a commission, you will want to draw a portrait of your client in her best, most attractive pose and expression. If, on the other hand, you are drawing the portrait for yourself, you may want to experiment more with the pose, costume or lighting.

Once the model is seated in the chair on the model stand, try to determine the best pose. Should it be a straight-on pose or a three-quarter view? You could try looking at the model from above, or the face may have interesting features that would make a strong profile portrait.

If you are doing the portrait for yourself, you may want to try a costume on the model. In my studio hang a couple dozen different hats: cowboy hats, derbys, fishing hats, women's broad-brimmed hats, hats with veils. A hat can help create a mood and add excitement to a portrait.

Keep an egg timer handy when drawing from a model. Set the timer for twenty-five-minute sessions with ten-minute breaks. This gives the model time to stretch and move around. It also allows you to get away from your drawing and return with a fresh eye. You may find areas that are incorrect on your drawing after getting away from it for a few minutes.

◄ Take time to view your model in different poses and lighting arrangements. Start with a straight-on pose and lighting from the top and to one side. Then experiment with other poses and lighting arrangements.

To help you find the best composition, try looking at your model through a viewfinder. This gives you an idea of what the image will look like in a frame. You can make a viewfinder by cutting two L-shaped pieces of mat board. They can be easily adjusted to form a rectangle or square to look through. You can also quickly form a rectangle with your hands through which to view the model, as shown on the previous page.

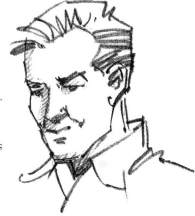

► Have the model move his or her head into different positions. In this case, the model has dropped his chin and is looking down as if in a pensive mood.

◄ Try looking down on the model from above for an unusual pose.

► Be on the lookout for models with interesting profiles.

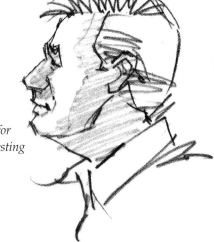

◄ It's a good idea to take breaks when doing a portrait. Use a timer and set it for twenty-five-minute poses and ten-minute breaks. This is a good time to get away from your work. You'll come back with a fresh eye.

Placement and Backgrounds

Placement of the portrait on the drawing paper is important. A general rule of thumb is that the chin of a head-and-shoulder portrait lies on or a little below the halfway line from top to bottom. If you have a three-quarter pose or a profile, leave a little more space on the side that the head is facing. Otherwise, the portrait will appear crowded and off balance.

Lighting is an essential part of creating the pose. Through lighting, you can create severe shadows that might be dramatic on a rugged male model, or you can shine the light source almost full face on a female model for a more delicate approach. Lighting will be discussed in more detail on pages 74-81.

Since we are focusing on head-and-shoulder por-

traits, the backgrounds should be kept simple. For example, you won't have room to include furniture in the background, but you might suggest a doorway simply by adding a dark vertical mass in back of the model. If it is to be a quiet portrait, you could leave middle to light value in the background. You may want to add a dark area in back of a light part of the head to bring it forward.

A handy addition to your studio is a standing changing screen set up behind the model stand. You can hang different value fabrics on it until you find the one that works best with the model and lighting arrangement.

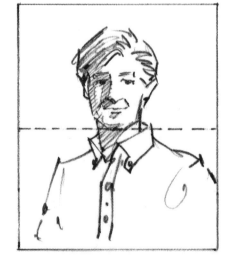

In a head-and-shoulder portrait, the chin usually comes close to the horizontal halfway mark on the paper.

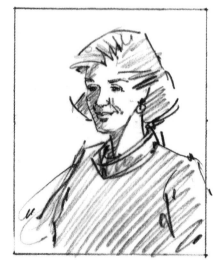

When the pose is a three-quarter view and the model is looking forward, keep more space in front of the model than in back, or the portrait will look cramped.

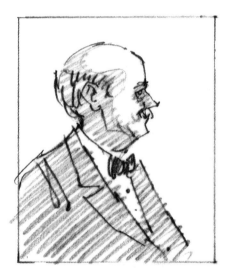

In a profile, allow a little more space to the side the model is facing to prevent a crowded look.

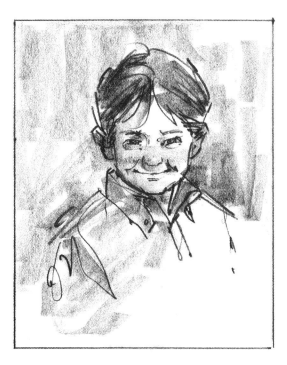

A middle value background, one that's not darker or lighter than the general value of the model's face, is subtle, suggesting a more tranquil mood.

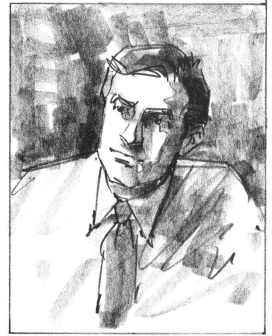

For a portrait with impact and contrast, use a dark background, particularly behind the light side of the head. Perhaps a lighter value could be used behind the shadow side of the head. This tends to push the head into the foreground.

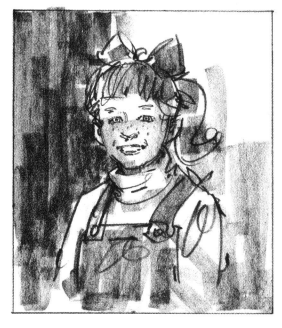

Sometimes a structure may be implied in the background by the use of values. Here, a dark panel in back of the model suggests a doorway.

By draping different value fabrics over a standing screen, you can quickly see what works best as a background for your model.

Lighting the Model

Two lights were used with this model: one soft light above and a little to my left of the model and a second bright light behind the model that caught parts of his left cheek, nose and chin. Although this portrait was done in the studio, it has the feeling of outdoors.

Most often, lighting is what makes a portrait interesting or dull. Lighting can set the place and mood. A child on a sunny beach, a sailor under a street lamp at night, a young woman reading by candlelight—all can be depicted with creative lighting.

If you're working with the light from north-facing windows, you can obtain the desired lighting situation by moving the model to various locations in your studio. However, if you don't have a north window or if you prefer a more interesting lighting situation, then you will need to use artificial light. In the next few pages, I will show you some examples of various lighting situations, including artificial and daylight.

Side Lighting

In this situation, half of the face is in light while the other half remains in shadow. At times, the shadow side may be too dark to distinguish features. You may want to use a soft light to lighten up the shadow side a little, or you can use a reflecting board (such as a piece of white foamcore board) to bounce the light onto the shadow side.

In this pose, the model appears to be next to a window. The lighting is soft and the portrait reflects a quiet and calm mood.

Three-Quarter Lighting

Because this lighting arrangement reveals the form of most of the facial features, it is ideal for portraits. Three-quarter lighting comes from above and to one side of the front of the head. One side of the face and part of the cheek on the shadow side are in light. Shadows appear under the brows, along one side of and under the nose, under the upper and lower lips and under the chin.

This lighting reveals all the model's features as solid forms. Since the light originates from above the model, the lightest area is on his forehead. The values of the face get slightly darker toward the bottom of the face, giving the appearance of a round or egg shape. The shadows alongside and under the nose make it appear to come forward. The highlight on the end of the nose reinforces this.

Frontal Lighting

Frontal lighting shines directly on the front of the face. This tends to soften the features. Only the dark areas of eyebrows, eyes, lashes, nostrils and lips are pronounced. This lighting arrangement is often appealing for women and children.

The model has turned toward the light. Now shadows no longer appear under brows or nose. Both cheeks are in light and only her eyebrows, eyes, nostrils, lips and hair are dark.

Top Lighting

Top lighting, as it sounds, comes from above the model. Very often the light source is a skylight. Light spilling down the forehead and onto a cheek or nose enhances these features and defines their form.

In this drawing, the light source is the sun at about noon. Notice how the light on the model's nose appears to bring it forward. The light on the pipe also has this effect. The dark background accentuates the bright light on the head.

Stage Lighting

With stage lighting, everything is reversed from top lighting. The light source is below the model as it is for stage performances. The shadows now appear above the lips, on top of the nose and over the eyebrows. This lighting can create a theatrical or mysterious mood.

The light source is below and to one side. Notice the light under the brows. Also the shadow on the side of the nose is cast upward rather than down under the nose. The mood is suspenseful, even ominous.

Rim Lighting

The main light source is behind and to one side of the model. This dramatic lighting is often used on men with strong features. It can also be desirable for women, since most of the face is in halftone light. The halftone light flattens form and enhances the dark features such as eyebrows, eyes, nostrils and lips.

Rim lighting dramatizes form when it contrasts sharply with the shadow areas of forehead, cheek and nose. In this situation the hair appears to have more depth and fullness.

Using Your Camera

Although nothing is better than working from a live model, photography can be a valuable aid in drawing portraits. Most beginning artists start by working from photographs. When I was a young boy, I used to draw from faces in magazines. Later on I found out how important it is to draw from a live model. When working from a model, you can see the subtle value changes that occur in both the light and shadow areas. In a photograph, shadow areas may appear black, while the light areas of the face may appear flat with little or no value changes. To interpret photographs successfully, you must first practice seeing and drawing values from life.

One of the great benefits of photography is that it allows you to capture fleeting expressions that would be difficult to do from life. With photography, you can work on the portrait when the model is unavailable, as well as at times that are more convenient for you.

CAMERA

To photograph your models, use a 35mm camera with a 70-200mm zoom lens or a 105mm lens. These lenses, unlike 35mm and 50mm lenses, produce an image with very little distortion.

When photographing a model, particularly in the studio, it's a good idea to mount your camera on a tripod and attach a shutter release cable to the camera. Using these items keeps the camera from moving while you're shooting. This is particularly important at slower shutter speeds such as 1/60 second or 1/30 second.

A shutter release cable is necessary to prevent shaking the camera at slow shutter speeds.

FILM

For black-and-white photography, I suggest you use T-MAX-400 film. When you're finished shooting, request a contact sheet from your developer. It will have all the images from a roll of film developed in a small format on one or two 8" x 10" film sheets. This allows you to quickly and easily review all shots. With a felt marker, circle the images that you want enlarged. Then ask your developer for 8" x 10" prints of your selected images. Another benefit of working with black-and-white film is that you can request an underdeveloped print to help you see what is happening in the shadow areas that may appear too dark in the normal print.

A simple spotlight mounted on a tri-pod works well for black-and-white photography.

LIGHTS

When photographing a model indoors, use one main light on a tripod. A second soft light or reflector board can be used to lighten up the shadow areas. To use the reflector board (white foamcore board), position it next to the model on the shadow side. Move the board until the reflected light from the main light source lights up the shadow area.

A contact sheet of all your exposures allows you to select only the shots you want for 8" x 10" prints.

Using a reflecting board can help lighten dark shadow areas.

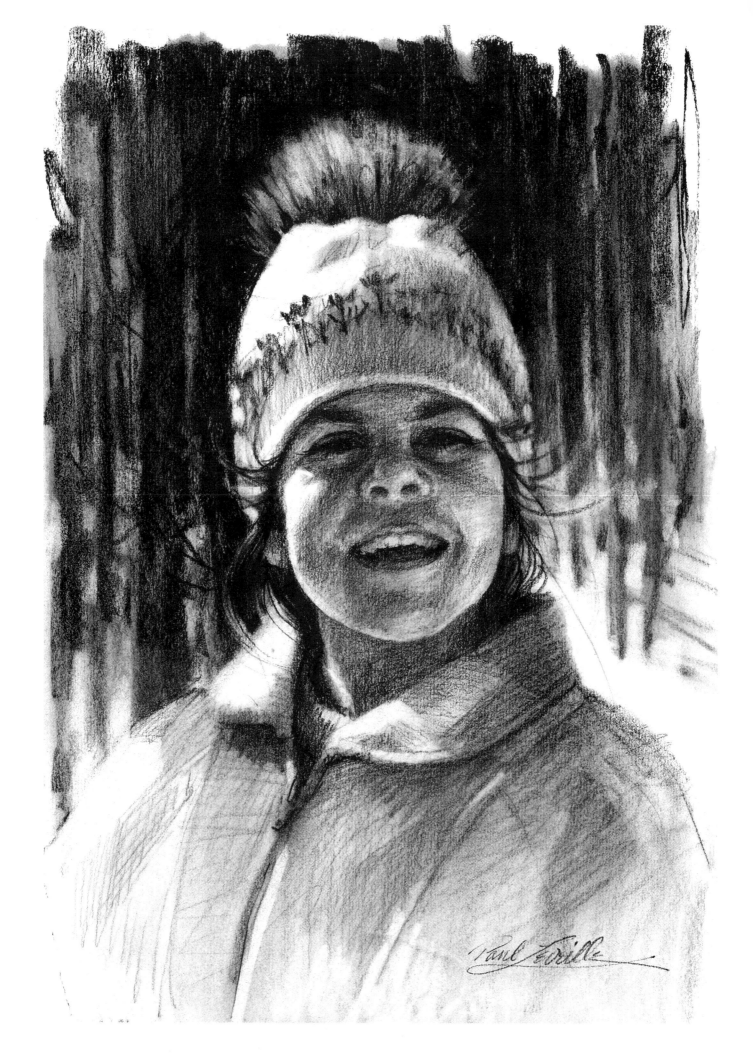

Drawing the Portrait Step by Step

I've found that most artistic people learn quickly from visual instructions. My mother, for example, can perform the most complicated knitting stitches or sew a dress for one of her grandchildren simply by referring to the visual instructions.

With this in mind, I produced the following portrait demonstrations. They show you how I start a portrait and how I proceed to finish. In addition there is information on the mediums and techniques that I use to achieve different effects. Papers from smooth to textured surfaces and lighting arrangements from artificial to bright outdoor lighting reveal some of the many possibilities for drawing portraits.

Like any new endeavor, learning how to draw portraits takes time. The important thing is to enjoy that time. Progress at your own speed and remember that the more you draw, the more enjoyment you will receive from it.

◄

WINTER HAT
Vine charcoal and 2B charcoal pencil on charcoal paper.

To maintain form and structure, it is important to light a model with only one main light source. In this drawing the snow has produced a strong reflected light on the shadow side of the face. However, it is not as strong as the rim lighting caused by the main source of light—the sun.

I softened all but a few of the designs in the hat. Too much detail distracts the viewer.

DEMONSTRATION 1

LITTLE GIRL WITH BRAIDS

WHAT YOU'LL NEED

- Strathmore 400 drawing paper
- 2B pencil
- 4B pencil
- Kneaded eraser

1 I selected a Strathmore 400 drawing paper for this portrait. The grain is not too coarse and not too smooth. The indirect outdoor lighting on this child produces very subtle changes in value and this paper allows me to capture those varied values more easily in pencil.

Working lightly with a 2B pencil, I make a mark for the top of the head and one for the chin. Then I proceed to draw the sides of the head. Next come the feature guidelines for eyes, nose, mouth and ears.

2 Still using a 2B, I use the side of my pencil to softly fill in the large dark shapes of hair and lighter shadow areas along the nose. I then rub the entire area lightly with my finger to achieve an even tone over the face.

By using the side of the pencil lead, I can quickly draw in large dark shapes such as the hair in this portrait.

 Switching to a 4B pencil, I
start to darken the big dark
areas. At the same time, I con-
stantly move about the portrait trying to
draw and redraw shapes more accurate-
ly. Notice that I have not gone into fine
detail on any one feature yet. All parts of
the drawing at this stage should be at the
same degree of finish.

For the subtle values on the face, I use
a 2B pencil. Rather than blending with
a tortillion, I want to create the subtle
value changes with my pen-
cil. To do this, I hold the
pencil lightly and, rather
than moving it back and forth,
move it in erratic patterns.
Slowly, I build the values this
way, from light to dark.

By moving my pencil in quick, erratic
strokes and varying the pressure, I can easi-
ly control the different value changes.

4 In the final stage, I darken the darks and refine the features. My pencil strokes for the hair are drawn in the direction of the flow of the hair, even in the braids.

To achieve the highlights and light halftones, I use a kneaded eraser. By shaping the eraser to a point and lightly tapping it on the drawing, I can lift small areas of pencil and control values.

DEMONSTRATION 2

WOMAN WITH DARK SKIN

<div>

WHAT YOU'LL NEED

- Canson charcoal paper
- 2B pencil
- 4B pencil
- 6B pencil
- Kneaded eraser
- Tortillion

</div>

1 I selected a sheet of Canson charcoal paper for this portrait. It has a slight tooth that works well with the techniques I intend to use. I start by finding the approximate top and bottom of the head and then add the sides. Then I add the feature lines. I move all around from the top of the head to the bottom and from side to side. With a 2B pencil I loosely sketch in the eyeballs, the bottom of the nose and the lips.

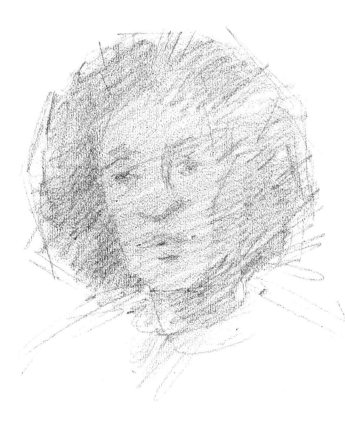

By rubbing my finger over my pencil marks, I can soften and blend them for an even skin tone.

2 Next, I lay in a tone over the entire portrait, first using the side of my 2B pencil, then rubbing the entire surface with my finger. This softens the pencil marks and creates an even overall tone.

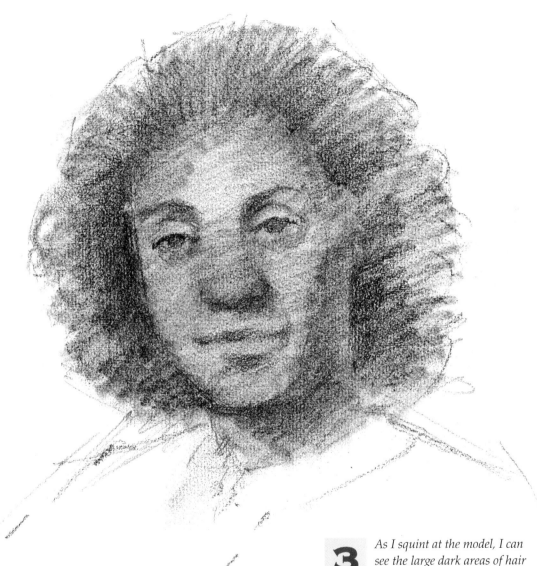

3 As I squint at the model, I can see the large dark areas of hair and shadow. I proceed to block in those large areas with a 4B pencil. I also darken the overall tone on the face a little more.

4 Now that I have the darks in, I use a kneaded eraser to pull out the bright areas of the face and hair. I continue to define the features, constantly moving around to different areas of the head.

To pull out the highlights in the hair, I simply flatten my kneaded eraser into a chisel shape. Then by pressing and pulling it in the direction of the hair, I lift pencil, leaving a light area.

By rubbing with a tor-
tillion, I can blend value
areas from dark to light.

5 In the final stages, I increase the density of the dark areas with a 6B pencil. I pull out the highlights on the end of the nose and the catchlight in the eyes. Using a tortillion, I soften some of the hard edges and halftone areas.

DEMONSTRATION 3

MAN WITH WHITE CAP

WHAT YOU'LL NEED

- Strathmore 500 charcoal paper
- Medium vine charcoal
- Sandpaper block
- Tortillion
- Workable fixative
- Kneaded eraser
- Pink eraser

1 *For this portrait, I am using a medium vine charcoal stick on Strathmore 500 charcoal paper. I start by sharpening the end of my charcoal stick on a sandpaper block. I then sketch the overall shape of the head, lightly sketching a line to indicate the top of the head and another for the chin. Then I proceed to the sides of the head, paying attention to the tilt of the head. Next come the feature guidelines on which I loosely sketch the features—eyes, nose, lips and chin (in this case, the bottom of the beard).*

By rubbing and rolling the end of a charcoal stick on a sandpaper block, I can shape it to a point like a pencil.

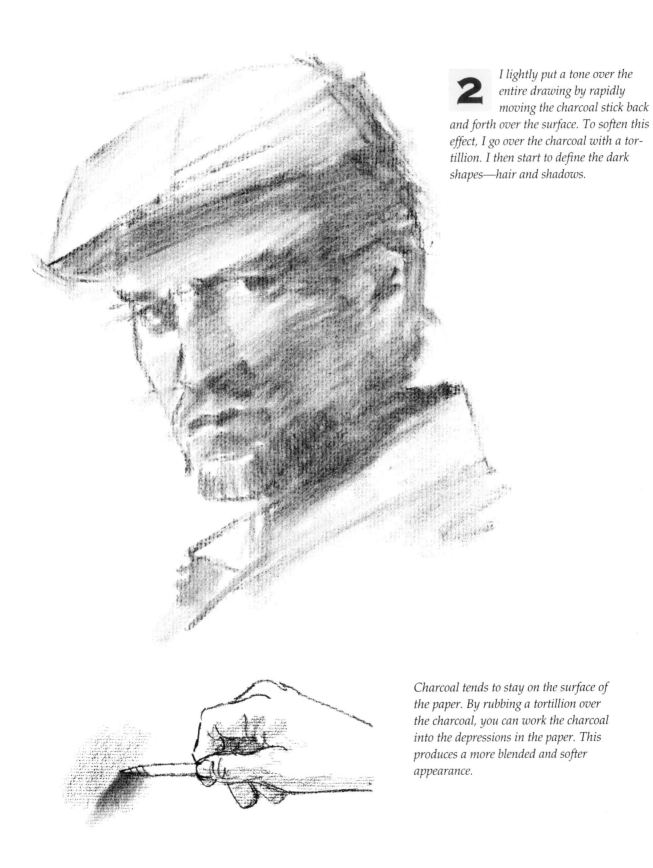

2 I lightly put a tone over the entire drawing by rapidly moving the charcoal stick back and forth over the surface. To soften this effect, I go over the charcoal with a tortillion. I then start to define the dark shapes—hair and shadows.

Charcoal tends to stay on the surface of the paper. By rubbing a tortillion over the charcoal, you can work the charcoal into the depressions in the paper. This produces a more blended and softer appearance.

3 At this point, it is getting harder to get rich darks. The paper won't hold more charcoal. So I will spray it lightly with workable fixative, which gives the paper more "tooth" for the charcoal to adhere to. But first, since spraying makes erasing more difficult, I pull out the light areas with a kneaded eraser. These areas include the hat, above the eyebrows, the cheeks, the top of the nose, around the lips, and parts of the beard. I leave more light area than is really there. This gives me room to render the subtle values leading up to the light areas. I also spend time developing the big shapes and the position of features. Now I'm ready to add a light mist of fixative.

There comes a point in a charcoal drawing when the paper will not hold any more charcoal. A light spray of fixative holds the charcoal that is on the paper and adds more tooth, so you can continue drawing. Keep in mind, however, that spraying makes erasing more difficult.

To erase after spraying a drawing with fixative, you may need to use a pink eraser, which is harder than a kneaded eraser. It usually does the trick.

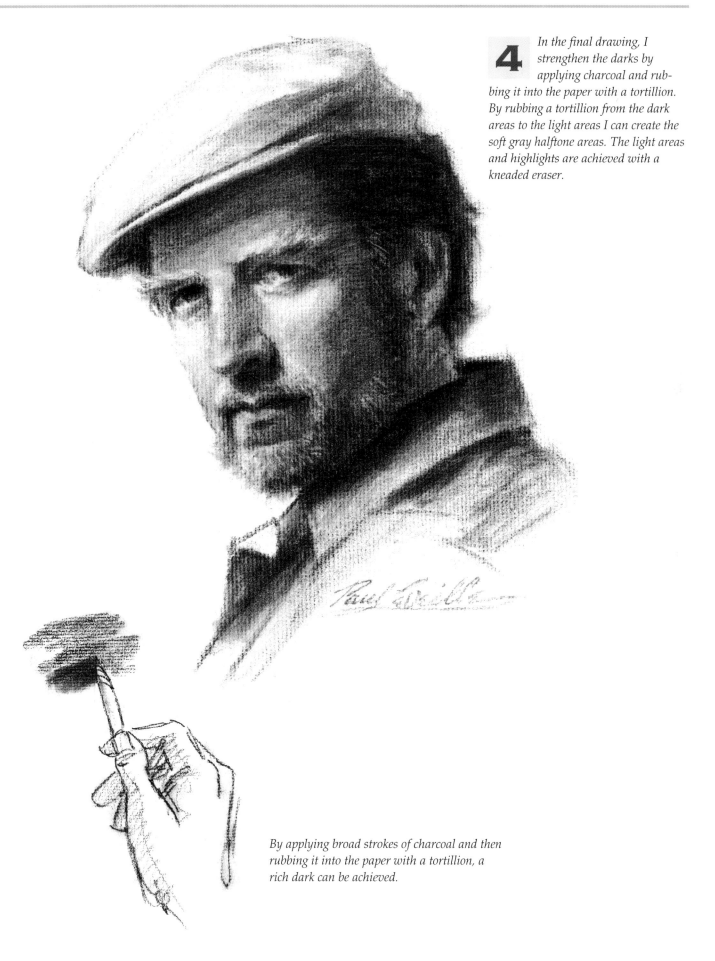

4 In the final drawing, I strengthen the darks by applying charcoal and rubbing it into the paper with a tortillion. By rubbing a tortillion from the dark areas to the light areas I can create the soft gray halftone areas. The light areas and highlights are achieved with a kneaded eraser.

By applying broad strokes of charcoal and then rubbing it into the paper with a tortillion, a rich dark can be achieved.

DEMONSTRATION 4
OLDER WOMAN

1 *For this portrait, I used a Strathmore 400 drawing paper. It has a mild texture that works well with pencil. I want to capture the soft and delicate look of this model. With a 2B pencil, I work loosely to determine the overall shape of the head and the feature lines. Although the model is looking straight out, her shoulders are turned slightly. I try to indicate this turn of the neck and shoulders by drawing the vertical curve of the neck and the direction of the V-shaped collar.*

To keep a more flowing, freehand approach, I use a pencil holder. This adds length to the pencil so I can hold it like a paintbrush. Now I can use my arm as well as my fingers to draw.

2 Using the flat edge of my pencil, I apply a tone over the whole head. To soften the tone, I rub the drawing with a tissue.

3 Now, by squinting, I can see the largest dark shapes. I loosely sketch in those dark shapes along the side of the face and neck as well as on the side of and under the nose. I continue to loosely develop the features.

4 Switching to a 4B pencil, I darken the big dark shapes. With a kneaded eraser, I pull out some of the light areas on the hair, forehead and nose.

At this time, I draw in the bow around the neck. To aid me in positioning the bow, I use my pencil as a plumb line. By holding my pencil vertically, I can see that the left side of the bow lines up where the model's right ear meets her jaw. The right side of the bow lines up with the left end of her lips.

By using a pencil as a plumb line, you can determine the relative position of shapes and features in your drawing. Hold the pencil lightly at one end and let it swing naturally into the vertical.

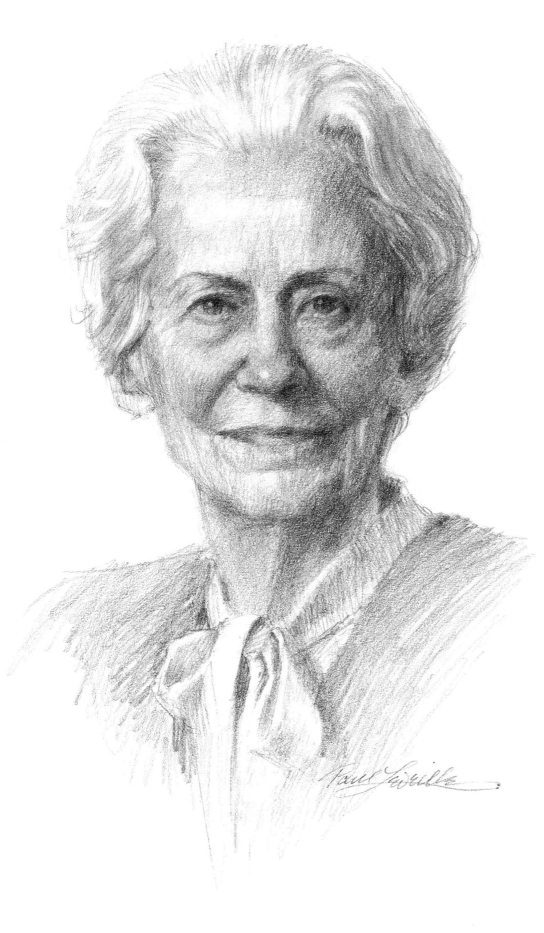

 5 *Holding my pencil like a brush allows me to keep a light touch and build up values slowly. A kneaded eraser is invaluable for achieving the light areas and highlights on the nose and eyes.*

DEMONSTRATION 5

MAN WITH GLASSES

WHAT YOU'LL NEED

- Canson charcoal paper
- 2B charcoal pencil
- Tissue
- Tortillion
- Kneaded eraser
- Clean piece of paper

1 *I chose a sheet of Canson charcoal paper for this charcoal drawing. Using a 2B charcoal pencil, I make a mark to indicate the top of the head and another for the chin. I then indicate the sides of the head and the feature lines. Keeping all my marks light, I start to loosely draw in the eyes, nose, mouth, ears and pipe. At this stage I'm not ready to make any definite commitment, so I only suggest the features and their locations.*

This model is wearing glasses. I usually draw models while they are wearing their glasses unless the glasses are tinted or are so thick that they prevent me from seeing the eyes. Glasses actually can be an aid to drawing the head, since they are a fixed form that you can relate the features to.

2 *The next step is to put a middle value tone over the face. This allows me to compare my dark and light values more easily. I tone the face by running the flat side of my charcoal pencil side to side from top to bottom. Then I rub the face area with a tissue to produce a flat, even tone.*

An even, flat tone can also be achieved by rubbing the drawing with a facial tissue.

By using the flat part of the charcoal pencil tip, I can cover a large area quickly. This is a good way to get an overall tone on the face.

 3 The next step is to go after the darkest shapes. Because the lighting on this model emanates from below and to his right, the dark shadows appear on his left side above the upper lip, above the nose and above the forehead. I also suggest some darker values on the model's right cheek and above the chin. The glasses get a little more attention at this stage.

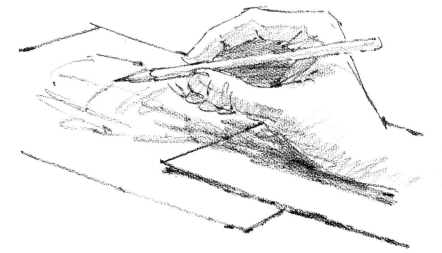

I use a clean piece of paper under my drawing hand to prevent smudging the drawing while I work.

4 Now I start to define the shapes of the features a little more, working all parts of the face to about the same degree of finish. The hair is drawn in with the flat edge of my charcoal pencil in the direction of the hair, as if I was combing it. I go over these marks with a tortillion to soften the effect. At this time I start to pull out some of the light areas of the face with a kneaded eraser. These areas include the neck, around the mouth, under the nose, the eyelids and the hair.

5 As in the previous stages of the drawing, I continue to work all parts of the head and stop when I am satisfied with the overall look. Notice that the angle of light has left the glasses without a glare.

An older person very often has accumulated some wrinkles about the eyes and mouth. Here I have not drawn the wrinkles on this model's face with the hard line of my charcoal pencil but have handled them gently by using a kneaded eraser for the lights and a tortillion for the dark areas.

DEMONSTRATION 6
YOUNG MAN IN SUNLIGHT

WHAT YOU'LL NEED

- Strathmore 500 charcoal paper
- Vine charcoal
- Kneaded eraser

1 *In this outdoor pose, the sun is behind and to one side of the model. Three quarters of the face is in shadow. However, the shadow side of the face is broken up with reflected light. The challenge is to capture the subtle values within the shadows without losing the form.*

With vine charcoal, I start sketching the overall shape of the head, working from top to bottom and side to side. I add the feature guidelines and then loosely suggest the position of the features.

2 *I quickly lay in a tone over the whole head by rapidly but lightly sketching with the flat edge of my vine charcoal stick. I broadly block in the large dark areas of hair and shadow. I rub the entire drawing with my finger. This fills in the valleys of this textured paper and leaves an even tone overall.*

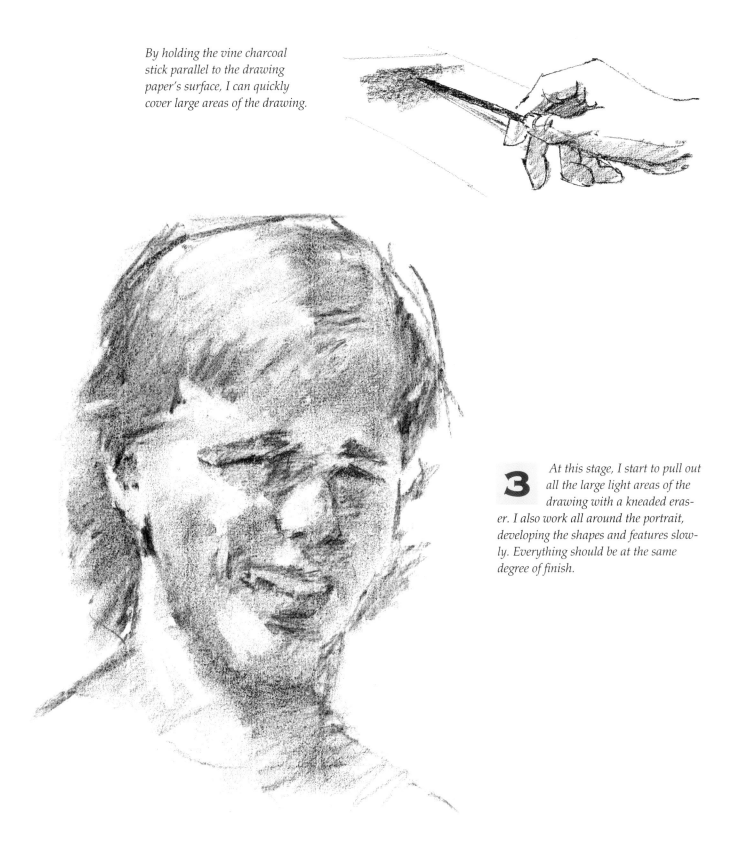

By holding the vine charcoal stick parallel to the drawing paper's surface, I can quickly cover large areas of the drawing.

3 *At this stage, I start to pull out all the large light areas of the drawing with a kneaded eraser. I also work all around the portrait, developing the shapes and features slowly. Everything should be at the same degree of finish.*

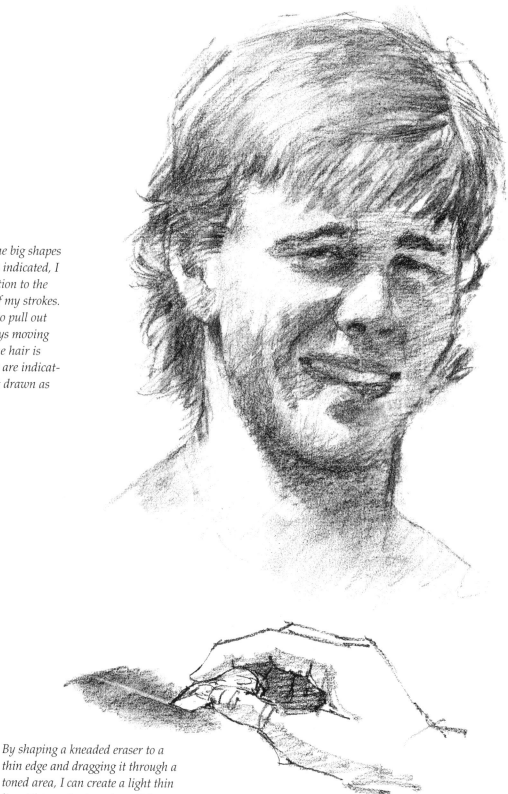

4 Now that I have the big shapes of darks and lights indicated, I start to give definition to the hair through the direction of my strokes. I also use a kneaded eraser to pull out light areas of the hair, always moving the eraser in the direction the hair is going. The teeth at this time are indicated only by a light shape, not drawn as individual teeth.

By shaping a kneaded eraser to a thin edge and dragging it through a toned area, I can create a light thin line. This method works well for indicating highlights in hair.

5 *I continue to refine the drawing with charcoal and kneaded eraser. When drawing from a model in sunlight, keep in mind that the model's eyes will naturally squint, even if the sun is behind him. Reflected light from the sky, a building, the water or a sidewalk can be very bright. Placing your model in a shaded area may help.*

DEMONSTRATION 7

DARK-SKINNED MAN WITH BERET

WHAT YOU'LL NEED

- Canson charcoal paper
- 2B pencil
- Kneaded eraser

1 For this pencil portrait, I chose a sheet of Canson charcoal paper with a distinct texture. I want that texture to be part of the drawing.

With a 2B pencil, I sketch the head in lightly, starting with a mark for the top of the head and one for the chin. I draw in the feature guidelines to help locate the positions of the eyes, nose, lips and ears. A series of quick strokes helps to loosely define the beret.

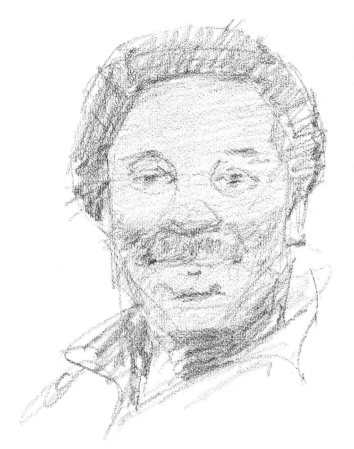

2 I continue to refine my drawing. At this point, I erase the feature guidelines and use the flat side of my pencil to apply an overall middle value tone over the face. By squinting, I eliminate most detail and can isolate the large dark shapes of the hat and under the chin. Using the flat side of my pencil, I lightly sketch them in.

With the side of my pencil, I can apply an even tone over my drawing quickly. This method also brings out the grain of the paper.

3 I'm still not ready to commit myself to details. I slowly build up the big dark areas and halftones. Once again, squinting helps me define the overall shape of the smile without being distracted by individual teeth.

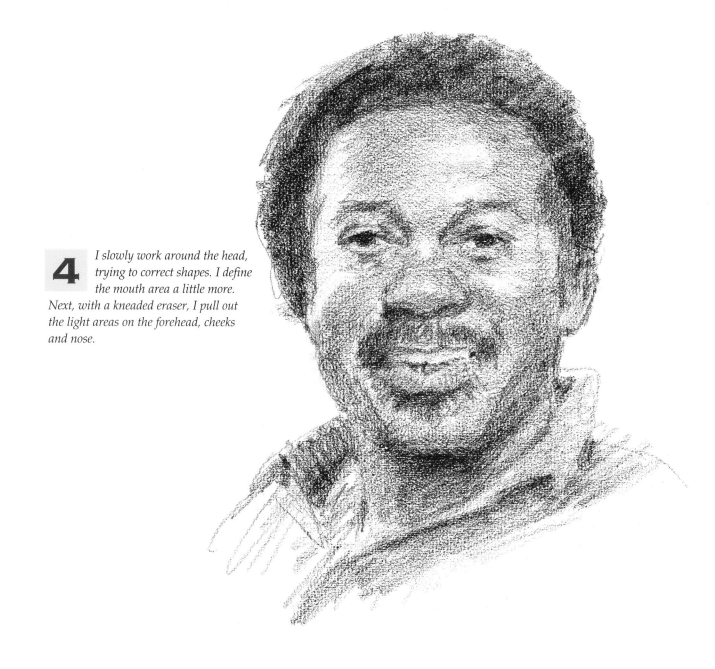

4 I slowly work around the head, trying to correct shapes. I define the mouth area a little more. Next, with a kneaded eraser, I pull out the light areas on the forehead, cheeks and nose.

By dabbing a kneaded eraser on the halftone areas, I can pull off enough pencil to leave a lighter area.

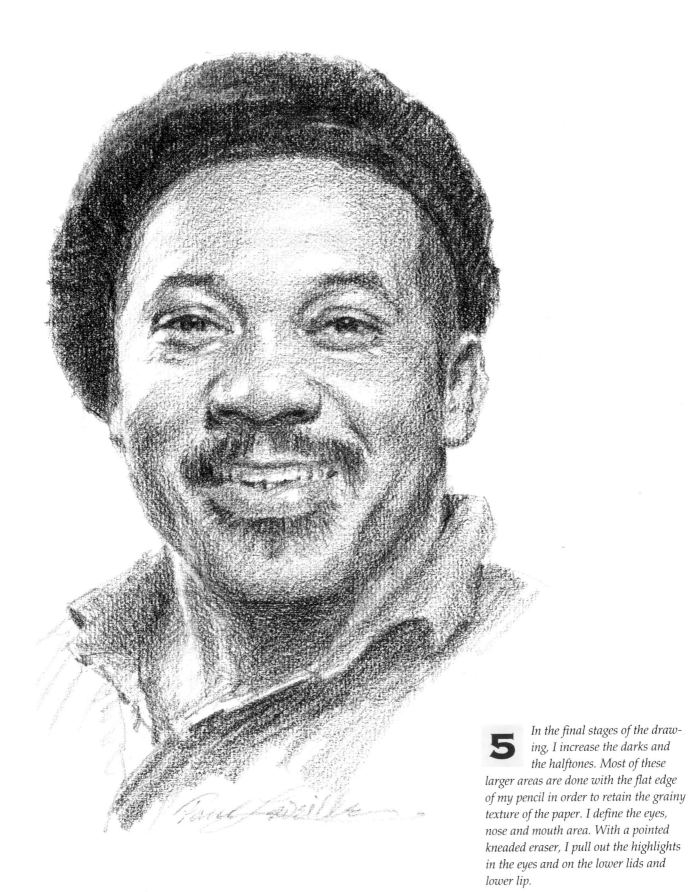

5 In the final stages of the drawing, I increase the darks and the halftones. Most of these larger areas are done with the flat edge of my pencil in order to retain the grainy texture of the paper. I define the eyes, nose and mouth area. With a pointed kneaded eraser, I pull out the highlights in the eyes and on the lower lids and lower lip.

DEMONSTRATION 8

PORTRAIT WITH DARK BACKGROUND

WHAT YOU'LL NEED

- Strathmore 500 charcoal paper
- Medium vine charcoal
- Compressed charcoal
- Kneaded eraser
- Tortillion
- Workable fixative

1 *Using a stick of medium vine charcoal, I begin to sketch the basic shape of the head on Strathmore charcoal paper. I then add the feature guidelines and loosely suggest the position of the features.*

Holding the charcoal stick at an angle almost parallel to the drawing surface produces a broad, even tone.

2 *I continue to refine my drawing, then lighten and remove the feature guidelines with a kneaded eraser. Next, I lay in a middle value tone of charcoal over the drawing by moving my charcoal stick back and forth while holding the stick almost parallel to the drawing paper. This produces a broad, even tone.*

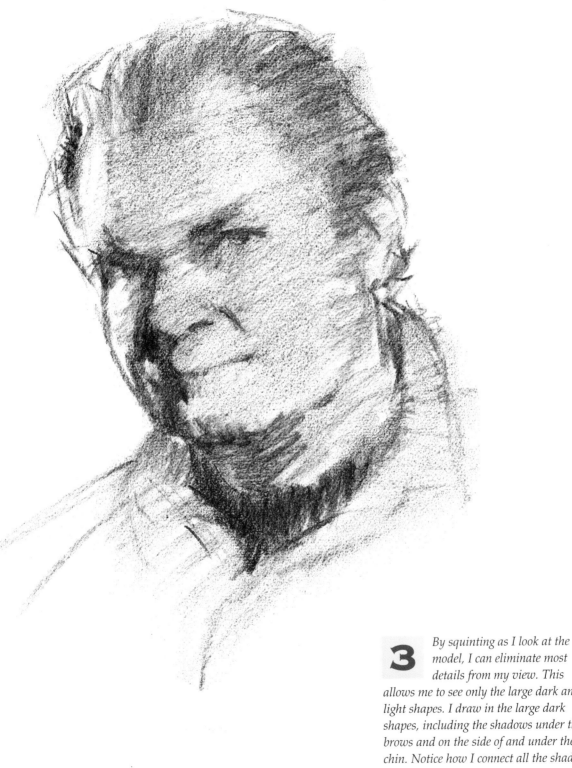

3 By squinting as I look at the model, I can eliminate most details from my view. This allows me to see only the large dark and light shapes. I draw in the large dark shapes, including the shadows under the brows and on the side of and under the chin. Notice how I connect all the shadows to make one large shape. I also include the hair and undershirt.

4 I squint again to find the large light areas and pull them out of the halftone areas with a kneaded eraser. I try to refine the features a little more. Next, I give the drawing a light spray of workable fixative. This helps the charcoal adhere to the drawing surface. It also adds new tooth to the surface that will hold additional charcoal as I continue to draw.

Now I switch to a compressed charcoal to achieve richer darks. I redraw the dark shadow areas and put in the dark background. The dark background adds contrast to the rim lighting.

A richer dark can be achieved with compressed charcoal.

5 In the final stage, I refine the features and develop the subtle value changes on the light side of the face with a tortillion and kneaded eraser. Notice that there is a highlight on only one eye. The other eye is in partial shadow, preventing the highlight from showing.

DEMONSTRATION 9

MAN IN SUIT AND TIE

1 In this demonstration, I will show you how to use tracing paper to start a portrait.

With a 2B pencil, I quickly sketch on tracing paper the overall shape of the head, the feature guidelines, and the placement of eyes, nose, mouth and ears. Since I'm working on a piece of tracing paper and know this won't be my finished drawing, I continue correcting by drawing and redrawing lines. By squinting, I concentrate on only the large dark values. I draw the dark shadows and hair in a very sketchy fashion.

2 *Rather than trying to refine the first drawing, I simply slide it under a clean sheet of tracing paper and trace a new drawing. I work carefully using fewer lines. When I have a drawing with features and shapes drawn in, I pull the first drawing out from under the one that I am working on. I continue to develop the second drawing, adding darker darks in the hair, on the side of the nose, under the chin and in the jacket. Since the final drawing will not be on this paper, I have more freedom with my pencil and I am less concerned about mistakes.*

With tracing paper, I can easily make many changes by tracing and redrawing corrections on a new sheet of paper with little need for erasing.

3 I could continue by using a third piece of tracing paper. However, I feel I have enough information to go directly to the final drawing paper. I've chosen a sheet of Canson heavyweight drawing paper, which I place over the tracing paper drawing on my light box.

Using the light box, I trace my tracing paper drawing on the final drawing paper. I keep my lines light at this stage as I continue to refine and correct my drawing.

Using a light box helps you transfer a drawing to a new sheet of paper. The light coming through the papers makes them translucent and allows you to see and trace the drawing on the new sheet of paper.

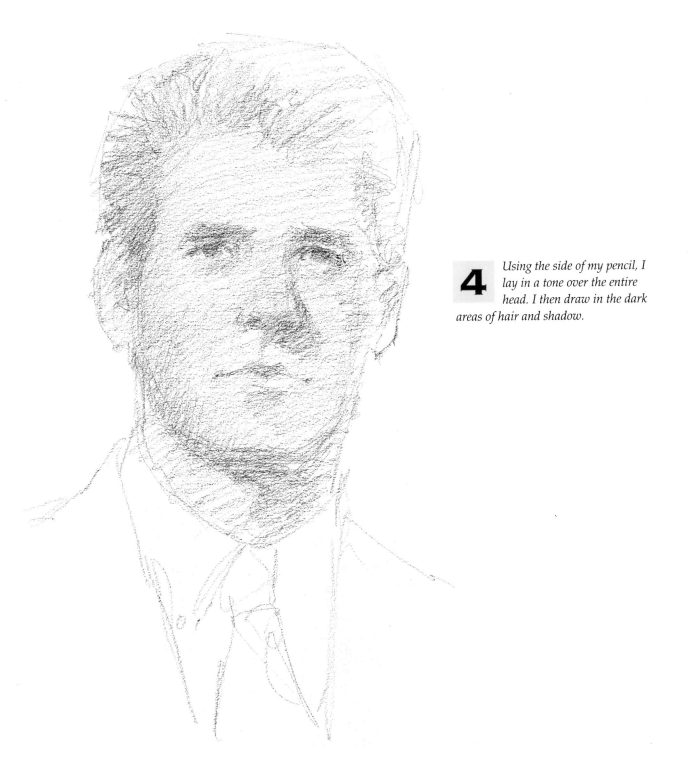

4 Using the side of my pencil, I lay in a tone over the entire head. I then draw in the dark areas of hair and shadow.

5 I continue to build up the values. Darks are enhanced, and I include the dark jacket and tie. At this time I also darken the background. This adds contrast to the strong rim lighting. With a kneaded eraser, I pull out the light areas along the sides of the head and nose.

6 In the final stage, it is now a matter of patience. Slowly, with a light touch, I build up the values and refine the features. I try to use the side of my pencil for the halftone areas. This allows the texture of the paper to come through.

Matting and Framing Your Artwork

Once you start drawing, it won't be long before you have some pieces that you will want to frame. Here are some easy step-by-step instructions for matting and framing a drawing.

Matting Your Drawing

When you feel that your drawing is completed, sign it, then spray it lightly with workable fixative to prevent smudging.

Framed drawings very often are enhanced by matting. I suggest that you use a double mat. It's attractive and it keeps the drawing from touching the glass. Although there are a multitude of mat colors, off-white or white always work well with pencil or charcoal drawings.

Measuring the Mat

Let's assume your drawing has an image that takes up an area of 15"

PREVENT SMUDGING
A light spray of workable fixative keeps your drawing from smudging.

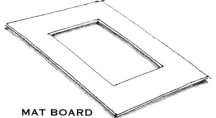

MAT BOARD
Mat board comes in many sizes and colors, but white or off-white works well with pencil or charcoal drawings.

by 18½" and you like to have a mat area of 2½" on all sides except the bottom. It's preferable to make the bottom of the mat a little deeper than the other sides because it will balance better. In this case, the bottom of the mat will be 3 inches deep. When you add the image area to the mat dimensions, you arrive at a frame size of 20" x 24".

Since you will be using a double mat, you will need to cut two pieces of mat board 20" x 24". Next, turn one mat over, and measure and draw lines for the 2½" top and sides and the 3" bottom. The second mat borders should be about ¼" smaller than the first. This allows you to see some of the first (or innermost) mat when the framing is completed. The measurements of the second mat are 2¼" on the top and two sides and 2¾" on the bottom. Measure and draw lines for these measurements on the back of the second mat.

Cutting the Mat

To cut your mats, you can use a mat cutter, a very useful and inexpensive piece of equipment. You can also cut your mat with a straightedge and a craft knife. However, you may discover, as I did, that a mat cutter will pay for itself many times over by preventing you from throwing out expensive mat boards ruined by bad cuts.

Gluing the Mats Together

After both mats are cut, turn them right side up and place the one with the narrower borders on top of the mat with the wider borders. When you have the mats situated exactly the way you want them, glue them together with a few spots from a

MATERIALS

Here is a list of materials needed to frame a 15" x 18½" drawing.
- Workable spray fixative
- (2) 20" x 24" mat boards (white or off-white)
- (1) 20" x 24" glass
- (1) 20" x 24" backing board (foamcore board)
- (1) 20" x 24" wood or metal frame
- Hot glue gun
- Masking tape
- Linen tape
- Box 1" brads
- Fitting tool
- White glue
- Brown wrapping paper
- Mat cutter or craft knife
- Razor blade
- Paper towels
- (2) ½" screw eyes
- Length (30") #4 picture frame wire
- Self-adhering bumper buttons

hot glue gun along the bottom panels. This will prevent the mats from moving and shifting during framing.

Attaching the Drawing to the Mats

Set the mats to one side, and lay your drawing face up on the table. At a position halfway down the drawing, attach a 2" length of masking tape to the back of each side of the drawing sheet. Leave about 1½" of each piece of the masking tape exposed, with the sticky side up.

Now, as you carefully position the mats over the drawing, press down on both sides of the mats directly over the masking tape. This will temporarily attach the drawing to the back of the mats.

Turn the mats and drawing over and attach two 1½" pieces of acid-free linen tape to the top of the drawing, leaving one half on the drawing and one half on the mat.

*Temporarily
attach
your draw-
ing to the
mat with mask-
ing tape at each
side.*

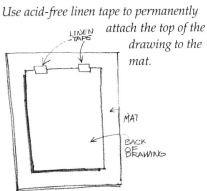

LINEN TAPE
Use acid-free linen tape to permanently attach the top of the drawing to the mat.

Hanging the drawing with two small pieces of tape at the top, as opposed to taping all four sides, allows the drawing paper to expand and contract with changing temperatures and humidity. Finally, remove the temporary pieces of masking tape.

FRAMING YOUR DRAWING

Clean a 20″ x 24″ piece of glass and insert it into your 20″ x 24″ wood or metal frame. Now place the matted drawing into the frame. Cut a 20″ x 24″ piece of foamcore board to use as a backing board, and insert it in the frame over the back of the matted drawing. To hold all pieces in the frame, use pliers to insert a one-inch brad into the frame at the center of each side. At this point, turn the framed drawing over to make sure that no dust specks or other foreign particles are between the drawing and the glass. If all is well,

place about four or five more brads on each side. If dust particles do appear remove the backing of the drawing from the glass. Take a pointed, kneaded eraser and touch the speck of dust lightly. It will adhere to the kneaded eraser. Resume the framing process.

Sealing the Frame
To seal the drawing, add a dust cover to the back. Cut a piece of brown wrapping paper slightly larger than the outside dimensions of the frame. With the framed drawing lying face down on the table, add a thin bead of white glue around the back side of the frame about ⅜″ from the outside. Place the oversized piece of wrapping paper over the back of the frame. Smooth the paper out, lightly rubbing the paper with your palms from the center to the sides. Once this is done, trim the paper ¼″ from the outside with a craft knife (or a razor blade and straightedge). To clean up any excess glue, just wipe with a wet rag or paper towel.

ATTACHING THE HANGING WIRE

The next step is to add a hanging wire. Insert ½″ screw eyes to each side of the back of the frame. To find the spot to put the screw eyes, measure down from the top of the

frame, one quarter of the entire length. If you are using a 1½″ wide frame, the outside length will be 27″ (24″ + 1½″ + 1½″). One quarter of 27″ is 6¾″. At 6¾″ from the top, mark the spots for the screw eyes.

Once the screw eyes are in, select a length of #4 picture frame wire that when stretched across the frame will extend about 3″ past each screw eye. Insert the end of the wire through the screw eye, wrap it around the base of the screw eye, then twist this short length of wire around the main wire.

Repeat the same procedure on the other side, leaving just a little slack in the wire. Stick self-adhering bumper buttons to both bottom corners on the back of the frame. This helps prevent the frame from sliding and tilting when hung on a wall. It also helps prevent the frame from marking the wall.

Last of all, put your name and address on the back of the framed drawing.

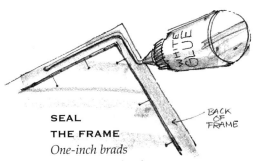

**SEAL
THE FRAME**
*One-inch brads
along the inside edge
of the frame hold the matted drawing in
place, while brown wrapping paper glued
along the back of the frame seals out dust.*

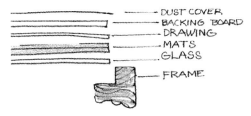

PICTURE FRAME WIRE
Draw the wire through the screw eye and then wrap the end of the wire around itself to secure it.

PICTURE FRAME IN LAYERS
A properly framed drawing is a composite of several materials all sealed together between the glass and the dust cover.